ART & GEOMETRY

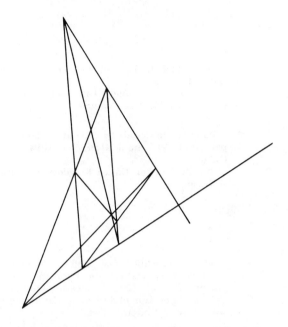

A STUDY IN SPACE INTUITIONS

BY WILLIAM M. IVINS JR.

DOVER PUBLICATIONS, INC. NEW YORK

Published in Canada by General Publishing Com-
pany, Ltd., 30 Lesmill Road, Don Mills, Toronto,
Ontario.
Published in the United Kingdom by Constable
and Company, Ltd.

This Dover edition, first published in 1964, is an
unabridged and unaltered republication of the work
first published by Harvard University Press in 1946.
This edition is published by special arrangement
with Harvard University Press.

Standard Book Number: 486-20941-5
Library of Congress Catalog Card Number: 64-15511

Manufactured in the United States of America
Dover Publications, Inc.
180 Varick Street
New York, N. Y. 10014

PREFACE

Seen in perspective, art, science, and philosophy are expressions of the same basic intuitions. Unlike science and philosophy, art has been kept insulated under a cheese glass of aloof exclusiveness. Until it is removed from its cover and placed alongside the other two in the open air of thought neither its values nor its implications can be perceived. By its very nature this task can only be done by the amateur, for no man can possibly be expert in the length and breadth of such a field. But, perhaps, after all, in all questions of value, it is the amateur and not the specialist who has the final word.

I owe more than I can say to the learned and unfailing willingness of kind friends and colleagues to disagree with me. Especially I am indebted to those who went so far as to read and criticize my manuscript. My daughter not only fought me through much of the text, but she prepared the necessary geometrical diagrams that accompany it.

<div align="right">W. M. I. Jr.</div>

The Metropolitan Museum of Art
December 1945

C O N T E N T S

INTRODUCTION

Some years ago the queer perspective in Dürer's prints led me to a superficial but painful acquaintance with a number of books about geometry, old and new. Among them was Federigo Enriques's *The Problems of Science* (Chicago, 1914). I was much interested by his remarks (p. 205 ff.) to the effect that the differences between metrical and perspective geometry could be traced back to the differences between the tactile-muscular and the visual intuitions of space. It occurred to me that, as metrical geometry was Greek and perspective geometry is modern, the same thing was, perhaps, true of the differences between Greek and modern art, and that it would be worth while to look into the matter.

Thanks to the plan and lay-out of the Metropolitan Museum, it had for many years been necessary for me to walk through its galleries of classical art on the way to and from my office in the department of prints. Thus, while I had no technical or book knowledge of Greek art, I was more or less accustomed to it and was not afraid to look at it for myself just as if it were any other kind of art. I began to look harder than ever at the classical objects, among which for a while there were arranged a group of casts of the more important and famous ancient statues, and I even read a few books and articles that dealt with them and especially with some other things.

It seems to me that the basic intuitional assumptions of any group of people must be sought among the things they take so much for granted that they are unaware of them. The easiest way to discover such unphrased basic assumptions is by approach from the point of view of a very different group of people with very different habits and ideas. To give a concrete example of this: The Greeks never mentioned among the axioms and postulates of their geometry their basic assumption of congruence, and yet if we come to their geometry from a geometry which is careful not to make that assumption, it is obvious that it is among the most fundamental things in Greek geometry, and plays a determining role in its form, its power, and its limitations.

The following essay is an account of part of my adventure in search of understanding. I hope that it may be of interest as an attempt, however amateurish and in spite of all the errors it undoubtedly contains, to deal with some long-range problems that are usually overlooked in the historical study of art.

CHAPTER I

EYE and HAND

My adventure began with some simple homemade experiments with my hands and eyes as the respective organs of the tactile-muscular and visual intuitions. Obvious and unexciting as their results may appear to be, their implications are of remarkable interest.

Unless the eye moves rather quickly, it is conscious of no breaks in the continuity of its awarenesses, although, of course, as seeing is a selective volitional activity, such breaks are many and great. Things emerge into full consciousness very gradually as they come into the field of vision. If, while looking straight ahead, we hold a hand out at full arm's length sideways behind the line of the two shoulders, we cannot see it nor are we visually aware of it. However, if we slowly swing the arm forward, we discover that long before we can see the hand we are visually aware of it. There are positions early in the swing of the arm from the side to the front in which we are not visually aware of the hand as long as it remains still but are aware of it as soon as it begins to wiggle or move. As the hand is swung forward from this range it slowly assumes shape and color, but the whole hand never attains its fullness of both for the unmoving eye. The smallness of the angle of sharp vision can be tested

by looking fixedly at a short word in a line of text and noticing how quickly the type in the words to its right and left loses definition, and that there are no points at which this loss either begins or finally culminates in a complete failure of awareness.[1] Because we can and do continually move our eyes without being aware that we are doing it, we are not usually conscious of this fading in and out, but we act on it continuously every time we walk down a crowded street.

If in a darkened room a red-point light is slowly swung from behind the shoulder line into the position of sharp vision for the unmoving forward-looking eye, it makes its coming into awareness in several different ways. It comes into awareness not suddenly but gradually, so gradually that it is difficult to say just when in its swing it does come into awareness. As it swings forward it gradually becomes more brilliant. Somewhere in the course of this swing a remarkable thing happens. When the eye is first aware of the dim luminous spot, the spot has a neutral greyish color. As it moves further forward it enters a region in which it changes color and becomes a full red.

To phenomena of this kind we must add the "after images." If we look fixedly at a pattern in bright red and then look at a piece of white paper we continue to be aware of the pattern, but as a pattern in green. If we look at a pattern of black squares separated by lanes of white, the lanes have flickering cores of grey. These things have much to do with the fact that our awareness of the hue of any particular portion of a surface depends in large measure upon its area and upon the areas and

[1] It is said that at a point two and a half degrees from the point of greatest sharpness of vision there is a 50 per cent decrease in acuity, and that at forty-five degrees the acuity has fallen to 2½ per cent. See "Wertheim's Curve" in W. S. Duke-Elder, *Text Book of Ophthalmology* (St. Louis, 1933), p. 924.

the hues of the neighboring portions and the comparative brilliance of their illumination.

In addition to things of these kinds there is the long series of visual effects that take place with changes in position. Objects get smaller and less brilliant as they get further away from us. Very distant objects are mere shapeless nubbins. Near objects continuously change their shapes as we move about them. A pine wood close to us is a mixture of deep greens and browns, but at a distance it becomes a diaphanous light blue. In the course of the day the whole landscape drastically changes its color. As the light decreases, the different colors disappear from view at different times. Parallel lines as they recede from us tend to come together.

Now, as against all this fading in and out, this shifting, varying, unbroken continuity of quite different visual effects, what do we discover when we examine the tactile-muscular sense returns given by the exploring hand? Doubtless these returns are extremely complex in themselves, but as compared with the visual returns they are definite, simple, and very restricted in gamut. To begin with, as we all know from our experiences in finding our ways about in completely dark rooms, tactile awareness for practical purposes is not accomplished by a gradual fading in and out of consciousness, but by catastrophic contacts and breaking of contacts. My hand either touches something or it does not. My hand tells me that something is light or heavy, hot or cold, smooth or rough. I can measure an object that is simple in form against a phalange of my thumb or a stick, and by counting my motions I can tell how many phalanges or sticks high or wide it is. Short of accident, my muscles tell me that these measurements always require the same number of movements, i.e., that the object does not change in size or shape. If the object is a molding, I can run my fingers or a stick along it and determine that

within the reach of my hand its lines are always the same distance apart and do not come together, i.e., that the lines are parallel. Furthermore, the fact that I can touch an object, hold it, push it, pull it, gives me a sense that there is really something there, that I am not the sport of a trick or illusion, and that this something remains the same no matter what its heaviness or lightness, its hotness or coldness, its smoothness or roughness. Moreover, the shapes of objects as known by the hand do not change with shifts in position as do the shapes known by the eye.

The hand, however, as compared to the eye works only within the short limits of reachable and touchable form. When detail gets small, the finger tips are unable to read it. When a form is large the hand cannot read it unless it is very simple in shape, and if it is very large the hand can only read limited portions of it. The hand is unable to correlate a series of simultaneous movements of different elements, and can gain little or no idea of the simultaneity of change in the shapes of the muscles and the limbs and body of an animal in motion. If a form in decoration is very simple and is repeated, like the egg and dart or the wave fret, the hand can follow and recognize it, but if it is complex and constantly changing without repeat, as in a rinceau or on a Gothic capital, the hand is at a very great disadvantage. In any continuous pattern the hand needs simple and static forms and it likes repeated ones. It knows objects separately, one after another, and unlike the eye it has no way of getting a practically simultaneous view or acquaintance with a group of objects as a single awareness. Unlike the eye, the unaided hand is unable to discover whether three or more objects are on a line.

Because of the fact that we frequently see objects at the same time that we touch them, we are apt to associate two different groups of sensations, so that we say that something looks heavy or dry or cold, although the eye

in fact is unable to know these sensations. But, it is important to notice that we never say anything feels red. Thus we are constantly giving visual expression to tactile qualities, but rarely or never reverse the process. The result of this is that, although the presence of a drawing on a sheet of paper escapes tactile detection, we can look at the drawing and say that it is composed in largest measure not of visual but of tactile awarenesses. Where an object visually overlaps another of the same hue and illumination its outlines are actually lost to sight, but our tactile intuition forces us to indicate its visually lost outline in our drawing.

As a result of all this I believe the tactile mind is very apt to be aware of and to think of things without any feeling of necessary relationship between them, except such perhaps as results from memory of an invariant time order of repeated but distinct and separate awarenesses.

Tactually, things exist in a series of *heres* in space, but where there are no things, space, even though "empty," continues to exist, because the exploring hand knows that it is in space even when it is in contact with nothing. The eye, contrariwise, can only see *things*, and where there are no things there is nothing, not even empty space, for that cannot be seen. There is no sense of contact in vision, but tactile awareness exists only as conscious contact. The hand, moving among the things it feels, is always literally "here," and while it has three dimensional coördinates it has no point of view and in consequence no vanishing point; the eye, having two dimensional coördinates, has a point of view and a vanishing point, and it sees "there," where it is not. The result is that visually things are not located in an independently existing space, but that space, rather, is a quality or relationship of things and has no existence without them.

From what has been said it is obvious that there re-

peatedly come crises when the visual and tactile-muscular returns are in conflict.[2] When this happens it is necessary that we elect for one or the other as the test of "reality." As we habitually elect for one or the other so we make assumptions on which we base our philosophies and our accounts of the world. I believe that the ancient Greeks provide an unusually clear example of this.

As nearly as I can discover, the Greek idea of a primary substance, or matter, having extension and located in an independently existing space, but set off against a lot of mirage-like secondary, attributable, qualities, may be regarded as the reduction of the tactile-muscular intuitions to a sort of basic philosophical principle. In many ways it would seem that such a central idea is destructive of any sense of necessary unity or continuity between things. It seems to me that running through most of what the Greeks did I perceive qualities that are difficult to explain on any grounds other than that intuitionally the Greeks were tactile minded, and that whenever they were given the choice between a tactile or a visual way of thought they instinctively chose the tactile one.[3] I can imagine nothing more antithetical to Greek thought than Nicod's remark that "the order of views thus be-

[2] A familiar example is the return from the crossed finger tips that there are two peas although the eye says there is only one. A more dramatic instance, as dealing with motion and not number, is afforded by the following trick. Make a pin hole in a piece of dark paper or thin cardboard. Hold the paper close to the eye in a position such that the light strikes through the hole to the eye. Then, between the paper and the eye, pass the head of a pin slowly up and down across the hole. When we push the pin head up, our eye tells us that it is going down, and vice versa. The scientific explanation of this contradiction in sense returns does not change them.

[3] We are apt to forget that in many ways the Greeks, even of the "great period," were a primitive people. For a bibliography of studies of the visual awarenesses of primitive peoples see Duke-Elder, *Text Book of Ophthalmology*, p. 886.

comes the only fundamental space of nature." [4]

Greek philosophers used the analogies of imitative art to illustrate their teaching about the unreliability of sensuous, and particularly of visual, apprehension and knowledge. Visual art was imitative and as such was a falsehood, and Socrates-Plato even went so far as to take a moral stand against it on that basis. [5] If I read the *Republic,* the *Sophist,* and the *Timaeus,* and Professor Cornford's commentary on the last of them, correctly, Greek painters and sculptors, and for that matter poets and dramatists too, were but imitations of Platonic ideas making imitations of imitations of Platonic ideas. [6] I sup-

[4] Jean Nicod, *Foundations of Geometry and Induction* (New York: Harcourt, Brace & Co., 1930), p. 182.

[5] See, e.g., the *Republic,* 603 (tr. Davies and Vaughan, London: Macmillan & Co., 1891), where Plato writes:

"Did we not assert the impossibility of entertaining, at the same time and with the same part of us, contradictory opinions with reference to the same things?

Yes, and we were right in asserting it.

Then that part of the soul, whose opinion runs counter to the measurements, cannot be identical with that part which agrees with them.

Certainly not.

But surely that part, which relies on measurement and calculation, must be the best part of the soul.

Doubtless it must.

Hence, that which contradicts this part must be one of the inferior elements of our nature.

Necessarily so.

This was the point which I wished to settle between us, when I said that painting, or to speak generally, the whole art of imitation, is busy about a work which is far removed from truth; and that it associates moreover with that part of us, which is far removed from wisdom, and is its mistress and friend for no wholesome or true purpose.

Unquestionably.

Thus the art of imitation is the worthless mistress of a worthless friend, and the parent of a worthless progeny."

[6] F. M. Cornford, *Plato's Cosmology* (New York: Harcourt, Brace & Co., 1937), p. 28: "The world, then, is a copy, an image, of the real. It is not, indeed, like an artist's painting at the third remove from reality; . . ."

pose Plato, from his extreme realist point of view, would
have called one of the Roman copies that today do duty
in our museums for so much of Greek sculpture the imi-
tation of an imitation of an imitation by the imitation of
an imitation—the cube of an imitation multiplied by the
square of an imitation, or imitation raised to its fifth
power or dimension of falsity.[7] I hesitate to think how
many powers of falsity Plato would have needed for a
so-called restoration of a Roman copy by a German pro-
fessor. Whatever one may think of rigmaroles such as
that which I have just perpetrated, they are more serious
than they may seem, and they account very satisfactorily
for the abstract lack of personality, the composite group-
photograph quality, of much of Greek art.[8]

In view of Plato's attitude towards art, little can be
more interesting than the fact that over the door of his
school there was an inscription which said "Let no one
destitute of geometry enter my doors." In the *Republic*,
527, he says of geometry that it is "pursued for the sake
of the knowledge of what eternally exists, and not of
what comes for a moment into existence, and then
perishes," and that it "must tend to draw the soul

[7] The results of "a copy of a copy of a copy," etc., are among the
most familiar qualities of much of the older book illustration. To any
one who desires to check this I can recommend a comparative study
of the illustrations in the early herbals, e.g. as reproduced in the pages
of Agnes Arber's *Herbals, Their Origin and Evolution* (Cambridge,
1938).

[8] A recent rereading has left me as much in the dark about
Aristotle's theory of art as I was when, more than forty years ago, I
first read S. H. Butcher's *Aristotle's Theory of Poetry and Fine Art*
(London: Macmillan & Co., 1902). If Professor Butcher was right in
saying (at p. 150): "If we may expand Aristotle's idea in the light
of his own system,—fine art eliminates what is transient and particular
and reveals the permanent and essential features of the original," it
would seem to be a theory of imitation based on a theoretical difference
between primary and secondary qualities. Thus, aside from Plato's per-
sonal moral stand, there seems to be little difference between the basic
assumptions of the two philosophers.

towards truth, and to give the finishing touch to the philosophic spirit."

The contrast drawn by Plato between the falsity of art and the truth of geometry was seemingly a commonplace, and so long as that dichotomy existed there was little chance that the similarities between the two would be recognized. Today, however, the situation has vastly changed. In the eighteenth century Berkeley made his destructive criticism of the distinction between the primary and secondary qualities or characteristics. In the nineteenth century and in this one, study of the relationships between logic and mathematics has brought about a much deeper understanding of what mathematics is. Today geometry has ceased to be The Truth and become a form of art marked by lack of contradiction above rather a superficial level. Thus, G. H. Hardy refers to "the real mathematics, which must be justified as art if it can be justified at all." [9] We know that the number of possible geometries is very large, and that any of them as a form of mathematics is only "true in virtue of its form." [10] Just what "true in virtue of its form" may mean seems not to be definitely known, but short of some very unforeseen implications it is probable that it applies equally well to both geometry and representational art.

[9] G. H. Hardy, *A Mathematician's Apology* (Cambridge University Press, 1940), p. 79.

[10] The phrase is Bertrand Russell's. See his *Principles of Mathematics,* 2nd ed. (New York: W. W. Norton & Co.), p. xii. In the preface to that edition he briefly points out some of the paradoxes or contradictions that infest the logical foundations of mathematics, and he deals with more of them in his text, notably in chapter xlii, where he discusses Zeno's "paradoxes."

GREEK ART

If we want to think clearly about art we must adopt as a guiding principle some sort of what the logicians call a doctrine of types. Otherwise we are all too apt to find ourselves talking solemnly, and even heatedly, about square circles and pink voids.

In the presence of various types of art based on different assumptions—e.g., Egyptian, Greek, Medieval, etc.—we can distinguish between them, discover their respective qualities, and explore their relations to ideas of all kinds, and we can, possibly, as a result of the study of their bases and their structures, say that one type of art is more primitive, less complex, or in various ways more restricted than another. To say, however, that an art of one type is intrinsically truer, better, finer, more beautiful, or more important than an art of another type, or that it would be improved by the addition of a missing quality or the deletion of one that is present, is to make statements that are meaningless. Moreover, when, in making great claims for an art, we deliberately leave out of our accounts moral and intellectual factors that are uncomfortable to discuss, we deliberately falsify.

It is always necessary to remember that a people's actual valuations of the past arts of its own tradition are to be sought not in the appreciative words it utters but

in the art that it currently produces. In this respect art is like logic, the history of which is to be sought in what men have done and not in the books they have written on logic. Every broad change in a living art is accompanied inevitably by a revaluation of the arts of the past, which frequently is of the most drastic kind. Such changes and revaluations are really the discoveries of new values, and, without them, art as vivid expression, far from having a history, could not exist. In the intervals that occasionally intervene between the exhaustion of a set of values and the discovery of a new one, what is called art is merely a skillful but dull and lifeless professional practice. The germs of the new values are usually to be found in what most people at the time regard as fumbling and incompetent performance, and what many people in later years may regard as decadence. Their actual character is not recognized for a long time to come.

In view of what I have just said, I shall not discuss or compare the aesthetic merits or demerits of either the Greek or the modern accomplishments. For the time being my interest is simply to discover and bring out, as best I can, the differences between the basic sensuous intuitions of the Greeks and of the moderns as exemplified in their so very different arts and geometries. The most direct way of doing this is by looking for qualities that are markedly present in one group and missing in the other. I shall, therefore, as a modern, content myself with pointing out the absence of certain significant qualities from both the art and the geometry of the Greeks, and then give a hasty sketch of how those qualities emerged in later times.

I shall not attempt to define the Greeks, or say where, when, how or how wonderful, etc., etc., they were, but shall take them frankly, in one of their own phrases, as an "undefined common notion." However, when we

try to think about any art it is always well to know, if we can, something of the history and the animus of the accepted ideas about it. I shall, therefore, point out briefly several things that are profitable to have in mind when thinking about what we think about Greek art.

Many of the accepted and conventional opinions about Greek art are merely academic survivals from a long vanished past. The idea that Greek art was the best and the noblest in the world and the norm by which the success or failure of all other arts was to be determined reached dogmatic form at a time when Western Europe had practically no first-hand acquaintance with Greek art and was vastly ignorant not only of the arts of its own past but of those of Asia and Egypt. That time, moreover, was one in which there was little understanding of the relativity and historicity of ideas and expression and in which just as students sought The Truth as an absolute in the thought of the past so they sought The Best as an absolute in the art of the past. The peculiar position of Greek art was very definitely a pre-non-Euclidean idea. It has survived to the present day principally because classical archaeology, as an accompaniment of classical scholarship, was the first and for long the only form in which art was known in the universities, i.e., places in which art was and is studied in its absence.[1]

[1] One of the comic aspects of this survival is provided by the many and striking changes that have taken place in specialist taste in classical art and the way that, prior to the reigning fashion for the primitives, the objects that were successively regarded as aesthetically the finest were attributed to the one "great period," the idea of which had been extracted from classical literature and not from acquaintance with the works of art. As to this see V. G. Simkhovitch, "Approaches to History," V, *Political Science Quarterly*, 1934, p. 44. The "scientific" quality of modern archaeology is well illustrated by the wide spread of the dates proposed by competent specialists for famous masterpieces, e.g. the Venus of Melos.

As compared to our long acquaintance with Greek letters, our actual acquaintance with Greek art is only of nineteenth-century origin, and, unlike our valuations of any other art, our valuations of it have been made and presented to us by specialists with very special assumptions, logic, and interests. Very few of these specialists give any signs of having either interest in or knowledge of any other arts. The necessary implications of these facts are many and very important. Vast inverted pyramids of industrious speculative learning about Greek art balance precariously upon fragile vertices of assumption and interpretation. To one acquainted at first hand with the difficulties of dating and attribution encountered in the work of such highly idiosyncratic and fully documented modern artists as, for example, Dürer, Rembrandt, and Daumier, the assurance with which ancient sculpture is dated and attributed seems little less than astounding.

Much of what we are told about Greek artists is based upon fragmentary and casual remarks by classical writers who lived centuries after the things they refer to and into whose words there have been read ideas that neither the artists nor the writers, as men of their times, could possibly have entertained. The accents and criteria of eighteenth- and nineteenth-century classicism and of the academic opponents of the Impressionist and Post-Impressionist movements ring strangely in the accepted accounts of what happened in the fifth and the fourth centuries before Christ. If Rembrandt's work had vanished and all we had to "reconstruct" it with were the remarks of Bartsch and Charles Blanc, each of whom in his time was a great specialist as compared to either Pliny or Pausanias, how strange our conception of it would be!

Another thing that has to be remembered is that words have a most horrid habit of changing their meanings in

the course of the millennia. What chance has a twentieth-century man of knowing what an ancient meant when he said that a now vanished work of art was "ethical" or "pathetic," or that a certain painter, none of whose work survives, was the first to give to his pictures "the appearance of reality"?

And lastly a remark that applies to all visual art of all kinds and schools: that, no matter what we are told by anybody, we cannot appreciate what we have not seen; and that when we have only read a description or only seen a "restoration" or a copy (or a composite of the "best" parts of a series of copies) of something, that something is a thing that we have no acquaintance with and therefore cannot appreciate.[2] It is marvellous what a cleansing of notions this simple epistemological idea can accomplish. The proof of this is to be found in the obvious facts that the practice of connoisseurship has been revolutionized and the history of art has been almost completely rewritten since the pervasion of the cross-line half-tone method of reproducing photographs on the pages of books. This pervasion took place roughly in the two decades from 1885 to 1905, prior to which most of art criticism was descriptive rhetoric and most of the pictorial reproductions available to students were hand-made copies, i.e., engravings, woodcuts, etc. No archaeologist today would attempt to base the serious work of attribution on those eighteenth- and nineteenth-century illustrations—but apparently many of them are willing to draw the most momentous conclusions about

[2] What can be the meaning of the word "best" when applied to one of a number of admitted copies of a vanished original attributed on the basis of a terse literary reference to an artist none of whose original work is known to survive? As it cannot mean that it most closely resembles the original, it can only be a statement of present-day tastes. And, that being so, where are we? It is extremely curious that so few of the original Greek figures that have come down to us are represented also by "Roman copies," and that the originals of so many of the "Roman copies" have never been found.

vanished originals from verbal descriptions, ancient
copies and modern restorations of them, and even from
the half-obliterated images on coins. The archaeologists
have here a problem that, so far as I am aware, few of
them have faced.

And now to come to Greek art itself.

At the very threshold of that art we meet the pecu-
liarity which most differentiates the Greek picture of the
world from that of modern times. This can perhaps be
indicated in the following highly untechnical way. The
Greeks represented Jim making a single gesture such as
he might use in a fight, and somewhere they represented
Jack making another such gesture, but they never rep-
resented the fight *between* Jim and Jack or the way in
which the gestures of the two fighters coalesced in a
single continuous rhythmical movement, such that each
gesture of the one had meaning through the series of
related gestures of the other. Any one who saw the
"slow movie" of the Johnson–Jeffries prize fight should
understand the unity of the shifting changing group and
the way in which, subject to the rules of the game, it
presents an unceasing flow of group forms out of and
into one another. This unity of the group in flow, to
which the Greeks were blind, has become the essential
aspect of the world for modern eyes.[3]

In the Metropolitan Museum of Art in New York
there are models of three very important Greek sites,
most carefully made from actual surveys and the detailed

[3] Those who prefer technical statements of such things may be re-
ferred to p. 79 et seq. of the late Ernst Cassirer's *Substance and Func-
tion* (Chicago: The Open Court Publishing Co., 1923), where there
is a properly philosophical account of Poncelet's principle of the per-
manence of geometrical relations. However, I have sometimes thought
how charmingly Greek it would be if scholars read fewer books and
attended more prize fights.

accounts of ancient travellers. They represent Delphi, Olympia, and the Athenian Acropolis. The immediately noticeable thing in these accurate models is that each monument, statue, theatre, temple, is placed wherever room can be found for it, like pots on an untidy shelf, with no thought of vistas or approaches, and no thought that any one erection could get in the way of or make any difference in another. The fact that these sites were built up over the generations on a group of sacred places does not account for the helter-skelter arrangement. As an excuse it admits the fact. The only thing that can account for that is an obliviousness to an interrelated or organized visual order.[4]

As nearly as I can make out, we get a reflection of this same thing in Greek architecture. The great problems of structure in architecture are to be sought in the support of the roof and floors over open spaces and the admission to them of light.[5] Starting from simplest wooden forms, the Greek architects at an early date effected a transformation of these forms into stone, but thereafter apparently contented themselves with the introduction of linear subtleties and applied ornament into the roughly standardized shapes.[6] The Heraeum at Olympia seems

[4] Henry Osborn Taylor, a typical apologist of the Greek idea, says "Apparently the Greeks did not extend their care for order to the relative situation of a number of buildings. No order can be seen in the arrangement of the buildings on the Acropolis of Athens. . . . But there results no lessening of the beauty of the temples, for that was intrinsic, independent of surroundings. A temple was so complete and perfect in itself that its situation relative to other buildings could not impair its beauty." (*Ancient Ideals,* New York: The Macmillan Co., 1913, I, 269.) The only escape from the contradiction is by appeal to the notion of "intrinsic" beauty, i.e., a hypothetical quality that lies beyond historicity and relation. This invocation of an absolute removes the matter under discussion from the realm of reason.

[5] It is remarkable how little is actually known as to the methods used in roofing and lighting the great temples.

[6] Professor Percy Gardner, writing on Greek art in the 11th edition of the *Encyclopaedia Britannica* (XII, 472), quotes his own *Grammar*

to have been a wood (and mud brick) building that was transformed, piece by piece, column by column, from wood to stone. If a large instead of a small temple was desired, it was achieved by the simple expedient of using more columns and longer walls. There was a remarkable absence of structural or organizational development in Greek building, in spite of the fact that the Greeks had eight hundred to a thousand years' time in which to display it.

It may be said that this was all because the function of the temple in the cult never changed, but again this is an excuse that admits the fact. I have never heard that the Greeks were either lacking in curiosity or averse to new fashions, but, if I may so express it, Greek building construction remained in the realm of simple addition. Adding more columns and lengthening walls, they remained within the tight limitations of a lintel construction. I have failed to find reference to any Greek voussoirs or ribs. They never used great vaults or domes so as to get large open interior spaces and vistas of light and shadow. The discovery of the principles of vaulting was eventually to reduce the Greek architectural forms to the status of mere decorative motives devoid of structural implication. For those who know how to read floor plans, the Greek lack of organizing thought in architectural construction becomes obvious on any comparison of the plans of the temples with those of the great Christian churches beginning, let us say, with Sancta Sophia in the middle of the sixth century.[7]

of Greek Art—"Instead of trying to invent new schemes, the mason contents himself with improving the regular patterns until they approach perfection, . . ." As one reads the whole passage one wonders whether in architecture, at least, the Greeks were not critical and finical rather than creative.

[7] One of the hardest-worked of the standardized clichés about the ancient Greeks is their love of order. The actual fact is that they had

When we come to such things as Greek sculpture, painting, and drawing, the problem becomes, as people say, more delicate. Here the point is not demonstrable by abstract measured plans of areas, and neither is it demonstrable in a story such as that told by Thucydides of an utter lack of organizing ability in the field of politics. Its data are immediate, concrete sense awarenesses or recognitions which are not mechanically measurable. In regard to these things each of us is a child of his time.

Speaking as honestly as I can from my own sense returns, the first things I am aware of in Greek sculpture are its abstraction or aloofness and its static quality. Its figures are frighteningly lonely. Each exists in a space by itself isolated from everything else in the world.[8] In consequence these figures have a remarkable lack of psychic tension. Despite the marvellous plastic qualities they occasionally exhibit, emotionally they have always been (and always will be) true first cousins to the square of the hypotenuse. Like the illustrations in our modern anatomies and physiologies, they are abstractions that

none of that creative sense of order that exhibits itself in the constructional organisms alike of Roman engineering and the cathedrals of the Middle Ages. In the seventeenth century Desargues and Pascal are said to have reduced hundreds of disparate Greek geometrical theorems to the status of mere corollaries of five or six basic theorems. As for the complete disorder that actually permeated Greek life and politics it is only necessary to consult the history of Thucydides and to look into the law and the practice of the Athenian courts.

[8] H. O. Taylor, summing up Aristotle's theory of dramatic unity, says: "The action must be complete, that is to say, must be a whole, having (1) a beginning which implies no necessary antecedent, but is itself a natural antecedent of something to come; (2) a middle, which requires other matters to precede and follow; and (3) an end, which naturally follows upon something else, but implies nothing following it" (*Ancient Ideals,* New York: The Macmillan Co., 1913, I, 288). It might be called the ideal of the exhausted bell glass or the catastrophic break in continuity.

have never known and will never know any heightening of their blood pressure.

I shall refer to but a few of the more famous and familiar pieces, mainly such as are, or were, always prominent in the cast galleries of the world. The growth of the knowledge of abstract exterior anatomy which is exhibited in these statues is probably remarkable, as is also the development of the techniques of manipulation, but the question remains whether sculpture that frankly aims at representation of the human being does actually represent it when it completely fails to give any indication of the emotional and volitional characteristics that are the peculiar and most wonderful attributes of its subject.

The early Kouroi, from the points of view of motion, emotion, and expression, are but the veriest stocks and stones. The great Olympian Apollo has many marvellous qualities, but he has never had a thought and he has no volition. He has never had an emotion and he is never going to move. The same thing is true of the figures from the Athenian Parthenon.[9] The well known Discus

[9] This is, perhaps, as good a place as any to introduce some typical specimens of the cautious, objective, unbiassed, scientific, statement that is the mark of much archaeological writing and that seems to be accepted as matter of course by its readers. First a great German authority speaks (Furtwängler and Urlichs, *Greek and Roman Sculpture,* New York: E. P. Dutton & Co., 1914, p. 62): "Ever since they have become known the Parthenon sculptures have been extolled by the greatest artists as a revelation of the highest point reached by Greek art, or indeed human art at any time. In their artistic conception, their technical perfection and triumphal union of realism and idealism they will rank as a standard for all times of the aims and limitations of plastic art. And they will contribute to the refinement of artistic taste and thereby exercise a beneficent influence on our modern art movements." The French equivalent we find in M. Collignon, *Le Parthénon* (Paris, 1914, p. 204): "Et c'est en effet comme le chef d'œuvre de la raison humaine qu'il [i.e., the Parthenon] s'impose tout d'abord à notre admiration." In the English equivalent we find Professor Percy Gardner saying, "The most marvellous phenomenon in the whole his-

Thrower can hardly be called a work of Greek art, as it is a composite restoration made up in modern times from the "best" parts of several Roman copies, but in view of its celebrity as a version of a statue by the Greek sculptor Myron, who is reputed to have been the first great master of motion, it is interesting to note that, just at the very moment when every fibre of the figure's mind and body should be at its most tense, its muscles are slack and its face is as calm and unruffled as a newly set bowl of junket.[10] The Hermes of Praxiteles, for all its grace and virtuosity, exemplifies the limp vacuousness and triviality of anything that has no relation to anything else. Here is one of the very few instances in which it is possible to check a technical word of Greek art criticism against an object to which it was applied by the Greeks. The word is "pathetic." One wonders what it meant in the mouth of an ancient Greek—certainly not what it means in the mouth of a modern Englishman or American.[11] Lovely as the Venus of Melos may be, she is the final epitome of all the dumbness of all the Dumb Doras —utterly devoid of thought, emotion, and expression. The so-celebrated Wounded Amazon drawing the arrow from her back is an incredibly dull and placid figurante in a provincial opera, her gesture not nearly as emotionally or psychologically valid as that with which

tory of art is the rapid progress made by Greece in painting and sculpture during the 5th century B.C." (*Encyclopaedia Britannica,* 11th ed., 1910, XII, 481). This last is particularly interesting in view of the fact that no Greek painting of the fifth century B.C. is known to survive. Much as archaeologists disapprove Plato's ideas about art they obviously have great faith in universals.

[10] The celebrated figures of the Tyrannicides, whether or not accurate copies, have all the expression and purposive gesture that we associate with the evolutions of a *Turnverein* well trained in its mechanical routine.

[11] I confess that I am unable to make any sense of the aesthetic distinctions between ἦθη, πάθη, and πράξεις, as explained by Professor Butcher, *Aristotle's Theory of Poetry and Fine Art,* p. 122 ff.

off stage she would have brushed a fly from her neck. As we look at Laocoön, we know, just as Wincklemann knew, that he has never really shouted and never struggled, and that he never will. Professor Bieber probably has it correctly when she wittily quotes Virgil as having said that Laocoön "intoned a fearful shout." [12] The Laocoön group is a learned exposition of conventional exterior anatomy, but it is also the ultimate triumph of academic ham acting, unless the palm should be awarded to the famous Florentine group of Niobe and Her Daughter. The well-known Old Market Woman, belonging to the Metropolitan Museum, is little more than a realistic study of a model, with no more personality than the pedantic studies of aged wrinkles and whiskers for their own sakes that were so beloved of certain older etchers of low esteem. Has anyone ever seen a Zeus, that allwise father, senior and most experienced of the gods, who was not a stiff and deadly stuffed shirt? He who should have the most history written on his face has the least. To judge from their portraits, the Greek gods and heroes neither thought nor cared. It was as fatal a weakness in the gods as it ever has been among men. [13]

Compare any single Greek figure to the quietly seated Pythagoras of the Cathedral at Chartres. He is only making an erasure in his manuscript, but his personality and the intentness and the tensions of his mind and body

[12] M. Bieber, *Laocoon* (New York: Columbia University Press, 1942), p. 8.

[13] The "progress" of Greek sculpture, at least as it is described and elucidated in many of the books, is so closely identified with increasing knowledge of external anatomy that it is not astonishing that at least one attempt should have been made to arrange a group of early statues of many different places of origin in chronological order according to their anatomical "truth." It would seem that such a mechanistic approach to an artistic problem involves a failure to appreciate art's creative and symbolic premises. If correct in its initial assumptions, it comes close to being a denial that the objects so classified are "art." Luckily the assumptions do not seem to meet with unanimous assent.

probably cannot be equalled in all of Greek sculpture. It is as perfect and concrete a demonstration of the non-sense of the Aristotelian definition of fine art as can be imagined.

I find no Greek groups that give me feelings comparable to those I get, for example, from Della Robbia's "Meeting of Saint Francis and Saint Dominic." These two saints are not attitudinizing anatomical generalities, but beings, or, as the medieval schoolmen might have said, *personae,* with minds and faiths and desires and wills and responsibilities, and in consequence there is more true movement in the tension of their quiet greeting than in all the Greek battle friezes and fighting metopes put together.[14] Nowhere in Greek art of any period have I observed anything comparable to the vivid, close-knit counterplay, physical and spiritual, that I find in such little etchings as Rembrandt's "The Agony in the Garden," and his "Christ Preaching" (le petit La Tombe), which turns their groups of persons, each with his separate character and personality, into single unified organisms.

Much is made of the Greek grave stones, but very few of them get out of the class of dull commercial manufacture—dummies of the same identical family of abstractions that decorate our own suburban cemeteries. They are, however, of great interest as showing how little the Greeks of their period actually used their eyes.

[14] Etienne Gilson, *L'Esprit de la philosophie médiévale,* Première série (Paris, 1932), p. 208: "L'homme se distingue donc des individus de toute autre espèce par le fait qu'il est maître de ses actes; à la différence de ceux que les forces naturelles agissent, il agit. Pour désigner l'individualité propre d'un être libre, on dit que c'est une personne." (Citing Aquinas, *Sum. Theol.,* I, 29, 1, Resp.) *Ibid.,* p. 212: "De toutes les choses admirables de la nature, dit le poète grec, je n'en connais pas d'aussi admirable que l'homme. A partir du Christianisme, ce n'est plus seulement l'homme, c'est la personne humaine qu'il faut dire: . . ." (Citing *Sum. Theol.,* I, 29, 3, Resp.). It is this "personne humaine" that I do not find in Greek art.

Many of them contain figures which we are told represent small children. Doubtless this is true, but, if it is, it demonstrates that the sculptors never really looked at a child. It is not until well into the Hellenistic period that we begin to find, as in the Sleeping Eros figures, any evidence of study of the forms of childhood. If we leave aside one or two amazing representations of the heads of horses, the Greek sculptors of the "great period" showed a similar indifference to the forms of animal life.

The simple fact of the matter is that the figures of Greek sculpture are abstract, ideological conformations, devoid of physical, mental, or spiritual histories. Such little emotion or movement as they have has no relation to emotional or volitional states. That this is a matter of point of view and not of earliness of date is shown by what we find in the work of still earlier peoples with different basic assumptions. Compare, for example, any of the Greek figures to the British Museum's Assyrian relief of a dying lioness or to the group of singing reapers on a well-known steatite pot in the museum at Candia. This leads to a matter of aesthetic theory that presumably is of some importance. I have never been able to understand why static relaxation should be considered either a closer approximation to the "permanent" or a more noble or more ideal aesthetic quality than emotional and purposive movement and stress, and have often wondered whether the idea that it is cannot be explained on the score that the academic aesthetic theorists of the end of the eighteenth and the beginning of the nineteenth centuries, at a period when there was a vast and overwhelming fashion for the "classical," set up a Greek peculiarity or inhibition as a general or universal criterion. As another example of this kind of fashionable extrapolation of ideas and their subsequent long life in academic circles, I may cite the Aristotelian categories,

which for hundreds of years puzzled and bothered the universities. It seems now to have been discovered that many of the complexities and difficulties of that doctrine can be traced back not to any profundity or subtlety of Aristotle's thought but to such purely local matters as gender in Greek grammar.[15] Thus it may be that Plato's characters knew what they were doing when they talked about the imitation of the imitation of an idea. Plato, after all, was one of the most intelligent men that ever lived, and, as a most consummate artist, may be supposed to have had some understanding of the artistic problem. It may be a very foolish idea, but it occurs to me that perhaps one of the reasons for Plato's dislike of the art of his time is its complete failure to deal with the characteristics that imply growth or "becoming."[16]

Nowhere in Greek art have I noticed, as I do in the Della Robbia and in the Rembrandts, a group of figures that defines or brings out a spiritual something that lies between them and that is of much greater importance than any of them—a something that lies far beyond the reach of tactile awareness. The composition of Greek work is that of the decorator who puts objects in agreeable conjunction but never makes them immanent in each other as they are in the great compositions of the Gothic and later periods. For this, curiously, it is possible to find proof as objective and mechanical as the plans of the sites and the temples.

This is so interesting and so significant that it deserves

[15] See T. Gomperz, *Greek Thinkers* (London, 1912), IV, 40 ff.

[16] It has been suggested to me by several of my knowing friends that much of my criticism of Greek architecture and sculpture is also applicable to the Greek tragedies. One of these friends gaily says that the basic form of the Greek tragedy survives only in the typical murder-mystery story of today—which starts with the discovery of a body (i.e., after the drama is over), is confined to conversation about what happened, and winds up with nemesis in the "death house." Never having read a Greek play, I content myself with passing these ideas along.

more than passing notice. The sculptures that once adorned pediments at Aegina and Olympia are justly among the most celebrated works of the Greek genius. There happens to be no record of how they were arranged on their pediments. The museums and the books contain various so-called restorations of the groups,[17] in which the component figures are set up and arranged in different orders from right to left. Had these figures had any visual or spiritual relationship to each other, had their order been something more than that to be found in any casual congeries of objects fitted conveniently into a given space, this could not be, for they would have had to fall into definite position, one order and no other.

Suggestive as are these particular sculptures, the most astonishing and instructive example of the kind is provided by yet another of the great masterpieces of Greek art. It is that of the celebrated battle friezes from the temple at Bassae or Phigaleia. The sculptured slabs ran around the wall. They were removed and sold before

[17] Again the questions of "composition" and "restoration." In Furt-wängler and Urlichs, *Greek and Roman Sculpture*, p. 10. I find it said: "Ninety years after the first exploration the [Aegina] temple precincts were thoroughly examined under Furtwängler's energetic and careful guidance; by means of new discoveries and renewed investigation of the old material, the reconstruction has been accomplished on which our exposition is based. The models in the Glyptothek, one fifth the natural size, arouse a lively interest in all beholders, partly on account of the restoration of the rich painting. Beside the harmonious completeness and rhythmic variety of the two pediments the scattered and defective parts of the original appear dull and tedious. . . . We now turn to the consideration of the sculpture itself and begin with the composition. The very first glance informs us that the statues stand admirably in the space, which slopes steeply from the center, adapting themselves architecturally to the pediment without appearing stiff, but rather suggesting the notion of vigorous life. Thus the difficult task of filling the narrow frame is solved. . . . The principal achievement of the artist lies in the space-filling, as simple as it is ingenious, the happy result of mature consideration. The chief groups taken by themselves are quite successful compositions, and every part is worthy of examination in detail," etc., etc. It may be that the German professors understand "Greek" art so well because they have made so much of it.

any record was made of their respective positions. They were taken up to London, where for about a hundred years intelligent men of all nations labored over them in the hope of finding out the order in which they had originally been set up. In addition to all the merely tentative orders that were suggested, there were at least six, so I am most authoritatively informed, that were in turn put forth as "definitive." Then at last a brilliant young American, who was subsequently to become the distinguished president of the Archaeological Association, solved the problem that had so long vexed the masters of Greek archaeology. Reasoning that as slabs fastened to walls the reliefs must have been held in place by dowels, he went to the still standing temple and there took measurements and rubbings of the spaces on the walls that had been occupied by the slabs. He took these up to London, where he compared the dowel holes in the slabs with his records of the dowel holes in the temple walls. In the most literal sense of the word he solved the ordering of these slabs behind their backs with no reference to their sculptured faces.[18] I can imagine no more pertinent comment upon the compositional integration of the frieze and the interrelation of its figures.

The extremely small number of Greek portrait heads is significant. Of the few that exist it is doubtful if any that is not very late is a sharply seen or realized record of the kind with which we are familiar in the art of the Romans and of the Middle Ages and other periods. They are what are called "idealized" or "ennobled" portraits, i.e., abstractions with only the faintest personal character and no psychological value—really no more than "composite group photographs." As by definition, the hallmark of "idealized" and "ennobled" representation is vacuity. This is the common "stuffed shirt" qual-

[18] See W. B. Dinsmore, "The Temple of Apollo at Bassae," *Metropolitan Museum Studies*, IV (1933), p. 204.

ity of most official portraits, ancient and modern. That it should be an outstanding quality of by far the greater part of classical sculpture should be and probably is indicative of many things, as is also the fact that it is a quality that is most frequently singled out for enthusiastic approbation. Compare any of the Greek portraits with Rembrandt's little etchings of the two Haarings, father and son! The Greek unwillingness or incapacity, for they come to the same thing, to cope with the peculiar psychic tensions, the this-and-no-otherness, of personality has long been acclaimed as a sign of loftiness of conception and ideality of artistry, but if we are really honest with ourselves and if we know anything about other arts, it is no more than a peculiar limitation of the Greek mentality.[19] I, personally, in spite of the portrait busts, cannot believe that Pericles had a vacant face. In any event, this trait ties in closely with the all but complete absence from Greek sculpture of emotionally valid gesture and facial expression, those two things without which spiritual unity in a group of figures is impossible. Awareness of them comes almost exclusively through visual channels.

Thick books, illustrated with hundreds of reproductions, have been devoted to the subject of Greek painting and drawing, but when we examine them we find that there is no Greek painting still in existence which, were it not Greek, would be given more than a moment's thought as art. I see no more reason to call the Italian

[19] "Ideal" and "idealism" are extremely ambiguous words with very different meanings in the languages of metaphysics and of the street. While it may be that Greek art is peculiarly marked by qualities that can be closely associated with philosophical idealism, that art is, in the language of the street, no more ideal than any other. The consistent and misleading use of this verbal ambiguity by the archaeologists to make unjustifiable claims for Greek art as compared with the arts of other peoples can only be explained in one or the other of two different ways, either of which is regrettable.

wall paintings and the Egyptian portraits of the time following the accession of Augustus, Greek, than those later paintings that bear the signature Theotokopoulos in Greek letters.

Most of the learned discussion of Greek painting is little more than an empty juggling of ancient texts which have been deprived of meaning by the destruction of the objects to which they refer. Nothing is more meaningless than conventional abstract words of praise or description which have been separated from the objects to which they were originally applied. Any work of art that no one has seen for several thousand years is at best a mere verbal tradition, and in any concrete sense we have and can have no acquaintance with whatever qualities it may have had. Art belongs in the vast realm of things in which it is essential to remember that "Was gezeigt werden kann, kann nicht gesagt werden." It is even truer in this realm that what can*not* be shown cannot be said. Very few writers on Greek art seem to be fully aware of this simple fact.[20]

[20] To avoid "personalities" the following typical quotations are taken from a highly respected authority of the previous generation, whose logic, however, is still current in his calling. Professor Percy Gardner, writing in the 11th edition of the *Encyclopaedia Britannica*, about Polygnotus, a famous Greek painter of the fifth century B.C., says: "Technically his art was primitive. His excellence lay in the beauty of his drawing of individual figures; but especially in the 'ethical' and ideal character of his art. The contemporary, and perhaps the teacher, of Pheidias, he had the same grand manner. Simplicity, which was almost childlike, sentiment at once noble and gentle, extreme grace and charm of execution, marked his works, in contrast to the more animated, complicated and technically superior paintings, of a later age." From this one might think that the writer was acquainted with the work of Polygnotus and his successors, but the fact is that none of it survives and that this account is based on the facts that "Fortunately the traveller Pausanias has left us a careful description of the paintings, figure by figure. The foundations of the building have been recovered in the course of the French excavations at Delphi: From this evidence, some modern archaeologists have tried to reconstruct the paintings, except of course the colours of them. The

Our principal acquaintance with Greek draughtsman-
ship is based upon the figures with which the Greeks
decorated their vases. Before discussing these drawings,
however, it may be well to look for a moment at the
pots themselves and especially at their shapes. If we look
at these vases naïvely and simply it is obvious that their
profiles are composed of cold, sleek, insensitive, me-
chanically regular, quasi-geometrical curves. I doubt
whether any one has ever seen a Greek vase the profile
of which had any of that personal quality which is in-
separable from the living, visual line.

But to return to the vase drawings: In the first place it
must be recognized that, charming as many of them are,
these drawings are distinctly a minor art of decoration,
in general not too far removed from manufacturing
craftsmanship. A few of the compositions, especially
among those that occur on the bottoms of the interiors
of the kylixes, are the last possible word of stylized,
dandiacal drawing, decorative spacing, and fashionable
arrangement in two dimensions—but beyond that they
do not go. They rarely have more than the most tenuous

best of these reconstructions is by Carl Robert, who by the help of the
vase paintings of the middle of the fifth century has succeeded in
recovering both the perspective of Polygnotus and the character of his
figures." As to the "grand manner" of Pheidias, Professor Gardner,
writing about that artist in the same encyclopaedia, says: "It is to be
regretted that we have no morsel of work extant for which we can
definitely hold him responsible." The statement is made by various
modern writers on classical art, though I have been unable to discover
on what authority, that Plato thought little of the work of Polygnotus.
As between the opinion of Plato, an unusually keen contemporary,
and that of the uncritical traveller Pausanias, who lived five or six
centuries later, the modern archaeologists have preferred that of
Pausanias and backed it up with the truly remarkable performance of
Carl Robert. In the (Loeb) *Critias*, 107, which, astonishingly, has
been cited to show Plato's attitude towards the Polygnotan innovations,
it is said: "For when the listeners are in a state of inexperience and
complete ignorance about a matter, such a state of mind affords great
opportunities to the person who is going to discourse about that matter."

emotional unity, and they never represent things as seen relatively to each other in three-dimensional space. It might be conceived that this failure to compose the pot drawings in three dimensions was due in large measure to the material and the function of these drawings, but unfortunately there is no reason to think that the Greeks had any such tender artistic consciences as this would imply. The reason, in all probability, was ignorance.

In the earlier Greek vase drawings the figures are arranged in a row on one level, in later pots they are arranged on several different levels, but the figures on all levels tend to be of the same size. This latter arrangement appears, from the description by Pausanias, to have been used by Polygnotus in his wall paintings. The standard archaeological explanation of this arrangement is that it is a device for indication of depth in a three dimensional space, and it has been called an "imperfect perspective." So far as I am aware there is no contemporary literary evidence for this notion. Certainly Pausanias gives no ground for such an explanation.[21] I can, therefore, only take it to be a theory worked out by modern students who, themselves thinking in visual terms, naïvely predicate that the Greeks did their best to think in the same way. This arrangement of equal-sized figures on different levels can be explained in another manner that is much more in consonance with the tactile habits of thought of the Greeks. When we look at a shelf or table covered with objects of the same size, those in the back rows are visually overlapped by those in the

[21] In Pausanias' descriptions of paintings by Polygnotus, as they are translated in the Bohn edition, I find no words to indicate that those paintings contained anything that showed or was taken to mean a recession in three-dimensional space. When Pausanias indicates the position of the figures it is confined to position on the picture plane. "Above the head of . . . is . . ." "Above . . . is . . ." ". . . next him sits . . ." ". . . in the same part of the painting is . . ." ". . . in the lower part of the painting is . . ." "If you look again at the upper part of the painting, you will see . . ." etc., etc.

front rows and appear to be smaller than they are. But, if we shut our eyes and reach out with our hands and feel the objects, not only are all the objects tactually of the same size but there is no overlapping of further objects by nearer ones. The only way of preserving these tactile awarenesses in a pictorial statement is by arranging the images of the objects in the picture plane in such a way that all the objects are of the same size and none overlaps another. The simplest way of doing this is by arranging the images of the separate objects in several nonoverlapping rows, one above the other. If we think about the matter in this way, the arrangement in rows becomes a pictorial device not to indicate visual depth but to save the tactile awarenesses, i.e., to represent things as they are tactually known. It seems to me, in view of the general Greek attitude, that this is what it was.

There is apparently nothing in the ancient remains or in the classical literature to show that prior to Roman imperial times there was any idea of a unified pictorial space, and even then only of the most rudimentary kind. I have happened on no evidence to show that any Greek ever sat down and drew a view, or a group of figures, or a congeries of objects, such as his tables and chairs, as they appeared relatively to each other in their respective shapes, sizes, and positions, as seen from a single point of view. The knowledge of perspective attributed to Agatharcus, Anaxagoras, and Democritus is a modern myth based on the utterly unwarranted reading into a casual remark by Vitruvius, who lived at least four hundred years later, of ideas that neither Vitruvius nor any Greek of the fifth century B.C. could possibly have had.[22]

[22] Vitruvius, Book VII, Intr. par. 11. The passage is so blind and ambiguous that the translations into English by Gwilt and Morgan, into French by Poudra and Choisy, and into German by Prestel, do not agree about the meaning of its phrases. Heath's account of it (Sir Thomas Heath, *A History of Greek Mathematics*, Oxford, 1921, I, 174) is not critical. On the dates of their *floruits* alone it is exceedingly

It is most unfortunate that students who would rightly hesitate before saying that the ability to foreshorten an arm or a leg implied a knowledge of perspective have no hesitation in making that claim in regard to the most incompetent foreshortening of single inanimate objects. I am unable to see any logical difference between the ideas underlying the foreshortening of the two different kinds of things.

Perspective is something quite different from foreshortening. Technically, it is the central projection of a three-dimensional space upon a plane. Untechnically, it is the way of making a picture on a flat surface in such a manner that the various objects represented in it appear to have the same sizes, shapes, and positions, *relatively to each other,* that the actual objects as located in actual space would have if seen by the beholder from a single determined point of view. I have discovered nothing to justify the belief that the Greeks had any idea, either in practice or theory, at any time, of the conception contained in the italicized words in the preceding sentence. Shadows cast by the sun are cast in orthogonal projection, which is quite different from central projection.

doubtful that any of the men mentioned by Vitruvius could possibly have written about the technical subject known today as perspective. If, a century before Menaechmus, and several before Euclid and Apollonius, these three men did actually write on a subject so interesting to mathematicians and philosophers as perspective, it is hard to think that Vitruvius, writing in the age of Augustus, should be the only ancient author to mention the fact. What to me, however, is the most telling argument against any such claim is that I have failed to find in the pages of Heath a single reference to central projection and section, i.e., to the geometrical basis of perspective. The mediaeval Latin word "perspectiva" meant not perspective but optics,—a very different subject and one about which Anaxagoras and Democritus may well have written. As to the various meanings of "Scena" see Pauly-Wissowa under Skene. Compare also E. Pfuhl. *Malerei und Zeichnung der Griechen* (Munich, 1923), II, 666. Professor Burnet in his *Early Greek Philosophy* (London, 1930, p. 257) is quite scathing about what Vitruvius said about Anaxagoras.

Thus the indication of shadows in a painting has nothing, necessarily, to do with perspective. The simple fact is that if any one modern concept had to be picked out as being most antithetical to Greek expression, practice, and habit of thought, it would undoubtedly be the essential relativity involved in the idea of the modern perspective.

Except for a few white-ground pots which, perhaps, show evidence of having been drawn from models, the Greek forms give every sign of having been drawn from memory of standardized objects seen from standardized positions. The Greeks struggled with the foreshortening of the individual body—sometimes successfully enough —but their foreshortening of one body had little bearing on the foreshortening of another in immediate proximity to it. The same thing is true of their notations of the shapes of objects. In general each separate body, each separate object, was seen as a thing in itself in a private space of its own. And, unless my eyes literally deceive me, the achievement of emotional or psychological relationships is of the greatest rarity.

My attention has been called to two particular vase drawings as showing that the Greeks did have a feeling for emotional unity in their visual art. One of them, by the so-called Penthesilea Master, represents Achilles piercing the heart of Penthesilea with his sword. The other, by Duris, represents Eos and the dead Memnon. Professor Swindler says of the Penthesilea drawing: "Here, Achilles is shown falling in love with the Amazon Queen, Penthesilea, at the moment when he drives his sword into her heart. The eye at last really sees and figures look into one another's faces. Although no deep romance may be read in this drawing, the interrelation established between the two figures by means of the eye is a new note." [23] The reproduction which

[23] M. H. Swindler, *Ancient Painting* (New Haven: Yale University Press, 1929), p. 179.

accompanies this statement shows that if the two figures can be said to use their eyes at all, which is very doubtful, they are looking away over each other's heads. The Duris drawing [24] is so damaged in its essential parts that no conclusion about emotional unity can be drawn from it. Eos' face is completely devoid of expression. Her arms have vanished. What is left of her body tells us nothing. Memnon is dead. With all the best will in the world I cannot see that either drawing proves the point it is adduced to prove. In any event it would have been a miracle if something that could be read as emotional unity by any one desiring to do so had not shown itself in at least a handful of the vase drawings out of all the thousands that were made.

And here I may make another point: it is my distinct feeling that any highly stylized linear art of representation, such as that of the Greek pot draughtsmen, has only the slightest chance of achieving emotional relationships or expression. Stylization means that your "hair do," your "make up," and your costume have become so very important to you that you don't do things that muss them up. There is nothing quite so mussy as real emotion or action. The same thing was said from another point of view, by Jean Cocteau, if I remember correctly, when he said "Stylization, word invented by the witty, to designate things that absolutely lack style."

Except on a few late white-ground pots, mainly the funereal vases known as *lekythoi,* the figures on the Greek vases are drawn with a series of even, unbroken contours in which the absence of modelling lines is noteworthy. This hard, insensitive outline is as prime an instance of the expression of tactile intuitions through a

[24] Reproduced in Pfuhl, *Malerei und Zeichnung der Griechen,* vol. III, pl. 164.

visual method of statement as can be desired.[25] Compare any of the Greek vase drawings to the drawings in the Dordogne and Altamira caves and to those that Degas made—to take examples of drawing that are based on visual intuitions and are as far apart in time as possible. Most of the reproductions of the vase drawings, even in such standard books as Buschor's *Griechische Vasenmalerei* and Pfuhl's *Malerei und Zeichnung der Griechen,* are made not from photographs of the originals but from modern flat copies by fourth-rate copyist draughtsmen. Those who know most about the Greek vases seem to be content with this kind of distorted reproduction, even to the extent of basing attributions upon it. These facts are full of the most interesting implications. One of these is that the drawings have little or no organic relation to the shapes of the pots they decorate. Another is that the space relationships between the figures in the drawings are of such little importance that they may be freely distorted without loss of anything essential. As every mathematician and every geographer knows, it is impossible to make a flat map of any portion of a curved surface, except a cylinder or a cone, that shall be free from distortion. And, as I can testify, it is impossible to make by hand a copy of a drawing that is not a misrepresentation of the basic quality of the

[25] An interior line defining a muscle or a fold of drapery is not *per se* a modelling line. The great draughtsmen have frequently indicated their contours by modelling lines. One difference between an outline and a modelling line is that an outline can usually be taken off with a templet while a series of modelling lines cannot. A modelling line, at least as the phrase was used in the studios forty years ago, indicates by its breaks, accents, and entries the disappearance from sight of a series of interrelated planes under tension. These same distinctions between outlines and modelling lines were made, apropos of the Greek vase drawings, in a somewhat different way by Alois Riegl on p. 120 of the second edition of his *Spätrömische Kunstindustrie* (Vienna, 1927).

original. These two facts constitute almost the first lesson in art connoisseurship.[26]

To sum up: It seems to me that the various qualities and lacks of quality in Greek work to which I have called attention—from the layouts of the sacred inclosures to the decorations on the vases—can in almost every case be traced back to the dominance among the Greeks of the tactile-muscular intuitions, and to the fact that those intuitions, far from leading to any sense of continuity or organic order, inhibit them. It is not inconceivable that this same thing led to the Greek failures in organization in so many of the things they attempted. If there was one thing which the ancient Greeks did not understand in any way it was "pulling together." [27]

Granting the intuitional premises of Greek art, much of it was very wonderful, but it must be seen within the limits of those premises and they must be kept clearly in mind when thinking about it, otherwise there is grave danger of trying to make comparative aesthetic valuations of it and other arts with equally valid but such different premises that aesthetic comparison between them is not only futile but nonsensical.

On concluding this chapter I cannot refrain from the two following remarks:

[26] From the point of view of one who works in a museum print room, the pretentious plates in many of the modern books on the vase drawings, e.g., A. Furtwängler und K. Reichold, *Griechische Vasenmalerei* (Munich, 1904, et seq.), tell a great deal about the taste of the time and country of their origin but peculiarly little about the quality as distinct from the iconography of the drawings on the Greek vases. The illustrations in E. Buschor's handy little *Griechische Vasenmalerei* (Munich, 1913) are made both from drawings of the originals and from photographs of the originals. The qualitative differences between the two groups are obvious and striking.

[27] It is interesting to note that until perhaps very recent times there has been little or no feeling for unified spaces in the painting of any of the Near Eastern countries dominated by the Greco-Byzantine tradition, and that the Balkan peninsula and Greece are still synonyms for ineradicable political disorder.

Classical art is a field of learning in which circularity of reasoning, explicit as well as implicit, is recognized as a legitimate procedure.

As science of the scientists knows no values and is incapable of dealing with the unique characteristics of personality, the claims of the archaeologists that their subject is a science and its methods scientific not only are interesting in themselves but explain many things that otherwise would be difficult to understand. One sometimes is sure that few archaeologists waste time thinking about Cleopatra's nose.

CHAPTER III

GREEK GEOMETRY

Let us now turn to Greek geometry, a subject about which I know little more than what I have been able to glean from turning the pages of Sir Thomas Heath's history.[1] The Greeks deserve all the credit that can be given them for their geometry,—but it should be remembered that it is only a very small portion of geometry, and that perhaps the most interesting thing about it is that just at the precise stage in its development when it was about to become most important and exciting the Greeks lost interest in it. Although Apollonius flourished about 200 B.C., that is, about seven hundred years before Justinian closed the Athenian Academy, his first important successors were Kepler and Desargues, who flourished shortly after A.D. 1600, that is, little more than a generation after the first decent edition (1566) of the portions of Apollonius that survived in the Greek.

As nothing else written in Greek, except the Epistles of Paul, the Elements of Euclid has been read and studied by the peoples of later times.[2] It was a codifica-

[1] Sir Thomas Heath, *A History of Greek Mathematics* (Oxford University Press, 1921).

[2] The fact that neither text is included in the academic and archaeological canons of "Greek literature" and "Greek philosophy" has implications of the most far reaching kind as to the validity of those canons and of the thought based on them.

tion and arrangement, according to the postulational
method, of most of the Greek geometry in existence at
the end of the fourth century B.C., with the notable ex-
ception of the conic sections. Each of Euclid's theorems
stands by itself, for it is very rare to find an individual
theorem that is deduced from a more general proposi-
tion.[3] It is important to notice that descriptive theorems
hardly exist in the Elements and that the dominant idea
of the book is the metrical one inherent in the two great
basic tactile-muscular assumptions of congruence and
parallelism.[4] The very etymology of the word geometry
shows that, in the minds of the Greeks who coined it, it
referred to a metrical study. To the Greeks any such
statement as that made by Professor Baker, in the first
volume of his *Principles of Geometry,* that "the present
volume . . . rejects the consideration of distance, and of
congruence, as fundamental ideas," would have seemed
preposterous and nonsensical, as would also Professor
Whitehead's statement that "geometry is the science of
cross-classification."[5] In their geometry the Greeks meas-

[3] M. Chasles, speaking about Pascal's theorem about the "mystic
hexagram," says "C'est cet art infiniment utile de déduire d'un seul
principe un grand nombre de vérités, dont les écrits des Anciens ne
nous offrent point d'exemples, qui fait l'avantage de nos méthodes sur
les leurs." See his *Aperçu historique sur l'origine et le développement
des méthodes en géométrie* (3rd ed., Paris, 1889), p. 73. Compare the
quotation from Cassirer, *infra* p. 101.

[4] Metrical theorems involve quantity or measurement; descriptive
ones deal with positions and do not involve quantity or measurement.
"Most of the propositions in Euclid's Elements are metrical, and it is
not easy to find among them an example of a purely descriptive
theorem" (L. Cremona, *Elements of Projective Geometry,* Oxford
University Press, 3rd ed., p. 50). "Two figures are said to be congruent
when one may be superposed upon the other so as exactly to coincide
with it" (*ibid.,* p. 63).

[5] H. F. Baker, *Principles of Geometry* (Cambridge University Press,
vol. I, 1929), p. vii. See also A. N. Whitehead, *The Axioms of Pro-
jective Geometry* (Cambridge University Press, 1906), p. 5. Compare
O. Veblen, and J. H. C. Whitehead, *The Foundations of Differential*

ured segments of lines, angles, areas, and volumes, and worked out many of the relationships between those measurements, but, just as in their art they never really studied spatial organization, character, or movement, so in their geometry they paid no attention to the inherent structural qualities of lines and never discovered such notions as those of duality and geometrical continuity.[6] I have not discovered that any Greek ever thought to wrestle with the problem presented by the order of the points on a line. Basically the Greeks thought about their geometry in terms of an unexpressed chalk line or yard stick which they held in their two hands. The Archimedean definition of the straight line as the shortest distance between two points is a perfect and basic instance of this, as is also the word hypotenuse, which means stretched against. The way Euclid proved his basic theorem (I, 4)—that two triangles, having two sides and the angle between them equal, are equal to each other— was by picking one triangle up and superimposing it on the other.[7] To any Greek the ideas that parallel lines

Geometry (Cambridge University Press, 1932), p. 17: "The question then arises why the name geometry is given to some mathematical sciences and not to others. It is likely that there is no definite answer to this question, but that a branch of mathematics is called a geometry because the name seems good, on emotional and traditional grounds, to a sufficient number of competent people." And "Any objective definition of geometry would probably include the whole of mathematics."

[6] "Duality" is the shorthand way of referring to the fact that as it is possible to define points, lines, and planes in terms of each other, descriptive theorems can be transformed (dualized) by simple rules into correlative theorems. The proof of a descriptive theorem carries with it the proof of its correlative. The principle is said to have been first enunciated by Gergonne about 1826. Geometrical continuity is discussed at some length later in this essay.

[7] In view of the fame of Euclid's book as an exercise in logic it is amusing to see that it takes the better part of two pages (pp. 405 ff.) of the close-printed second edition of Bertrand Russell's *The Principles of Mathematics* to point out some of the fallacies, errors, and un-mentioned assumptions contained in this theorem. ". . . Euclid's proof

could be said to meet at infinity, that two straight lines could be a curve, or that A times B is not necessarily the same as B times A, would have seemed sheer madness.[8] The meaning of all these things is quite simply that Euclid's geometry was based on the tactile-muscular intuitions. It is further important to notice that neither Euclid nor any of his Greek successors made any use in proof of the idea of infinity.[9] The tactile-muscular awarenesses of things are awarenesses of things here, literally at hand. Infinity, wherever it is, as by definition escapes

is so bad that he would have done better to assume the proposition as an axiom."

[8] It is doubtful whether any Greek would have thought it possible that these diagrams could illustrate the same identical geometrical theorem.

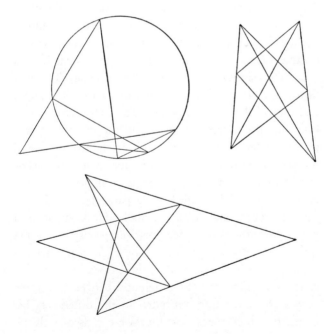

[9] See Heath, *History of Greek Mathematics,* I, 272.

handling and measurement. Intuitionally it belongs in the field of vision.

The historical development of a simple geometrical idea can perhaps be most easily traced, not in the Elements, but in the conic sections. Menaechmus, a contemporary of Plato's, is said to have been the first to investigate these curves, and to have done it about 360–350 B.C. Eutocius, a commentator of the fifth century of the Christian era, tells us, apparently on the authority of Geminus, a mathematical philosopher of the first century B.C., how the "ancients" proceeded. Assuming that Menaechmus was one of the ancients, the way in which he went about his task is of unusual interest not only for what he got but for what he missed. First, he had to generate his cones. This he did by revolving a right angled triangle about one of its sides adjacent to the right angle. The hypotenuse thus became the generator of the cone, one of the other sides became its axis, and the remaining one a radius of the circle that was its base. The base was an integral part of the cone as thus generated. In this way Menaechmus made three different cones. The vertical angle of one was acute, that of another was right, and that of the last was obtuse. Through each of these cones he then passed a plane in such a way that it was perpendicular to the generator, i.e., to the hypotenuse of the generating triangle. Three different plane sections or curves were thus produced. The acute-angled cone gave an ellipse, the right angled one a parabola, and the obtuse one, one branch of a hyperbola. He went on to a partial investigation of the metrical properties of the three plane curves so produced. The angle of intersection of his plane was the same in all three cases, but the three cones were different. The differences between the three curves were therefore attributed to the differences between the three cones, and they were consequently re-

garded as three absolutely different things. It was a prime case of tactual procedure and reasoning.[10]

After Menaechmus, Euclid wrote a treatise on the conic sections but it is now lost, though it has been conjectured that it corresponded to the first three books of Apollonius. When Archimedes' time came he, too, did important work on the conics. Apparently he recognized that all three of the conics could, by varying the angle of the secant plane, be obtained from any circular cone whatever, no matter what its vertical angle or the inclination of its axis, but he seems to have made no generalizing use of this knowledge. He also knew that if a cone were cut by a plane intersecting all its generators, the section was either a circle or an ellipse, but this seemingly did not cause him to include the circle among the curves known as the conic sections.

Apollonius, who came still later, a century or more after Menaechmus, was apparently the first to base the theory of conics on the fact that all three of the standard conics could be produced by the section of any one circular cone. He realized that, given a circle in a plane and a point outside the plane, he could generate a cone by anchoring a line to the point and swinging it around through the points in the circle. In this way he produced a double cone composed of two balancing halves either side of its vertex. When he intersected this by a plane in such a way as to produce a hyperbola, he got a two-branched one instead of a single-branched one. Seemingly these discoveries of Apollonius have always been regarded as among the most remarkable generalizations to be found in the history of Greek mathematics. I

[10] It is interesting to notice that, so far as is shown by Heath, the Greek geometers confined their interest in sections to the curves made by the sides of cones and never investigated the results of sectioning a group of intersecting planes.

should think that the recognition of the two-branched hyperbola as a single curve was possibly the outstanding example in Greek geometry of visual intuition.

According to Heath, Apollonius made his enunciations as generally as he could so that they would cover as many as possible of the curves generated by the section of a cone by a plane, including among them the circle. But Apollonius, like his predecessors before him, never thought of the two straight lines produced by passing a secant plane through the vertex of a cone as being a curve of the kind known as a conic section. He knew about the foci of the ellipse and of the hyperbola, but because the foci of a circle coincide he never recognized that as a conic section it actually had two foci, and he seems to have been completely ignorant of the second focus of the parabola. What this means is that he did not know how to bring the three limiting cases in the series of conics into a generalization. It is easy to see how two straight intersecting lines would not have impressed a Greek as being a curve. Apollonius knew, as had Euclid before him, that an oblique section of a cylinder produced an ellipse, but he did not recognize that a cylinder was the limiting case of a cone or that a section of a cylinder parallel to its axis would produce a curve, for in this case the curve would have been two straight parallel lines, and to have called them a curve would have been sheer nonsense to a Greek. The possibilities for generalization that were missed were of incalculable importance. The failure can be traced directly back to the inhibition which the tactile-muscular intuitions placed in the way of the idea of geometrical continuity. The three limiting cases—the line pair (which they did not recognize), the parabola, and the circle—were, for the Greeks, complete metrical or tactile breaks in any continuity, and prevented them from seeing the unbroken

visual evolution or transformation of configurations within a general definition.

There are two metrical ways of expressing this continuity among the conics, one by the focus-directrix ratios, and the other by the focal ratios. The focus-directrix ratio is that between the distances from a point on the curve to a point and to a line. The focal ratio is that between the distances from a point on a curve to two other points. As Apollonius nowhere mentions the directrix it is to be presumed that he did not know the focus-directrix ratios.[11] As for the focal ratios, he knew only those of the ellipse and the hyperbola. Thus even if he had some mystical sense of the continuity he could not have expressed it in the tight tidy way the Greeks demanded in their geometry. So far as is definitely known, it was not until the very last days of the ancient geometry, say five hundred or so years after Apollonius, that Pappus made the first general statement of the directrix-focus ratios for the three standard conics—the ellipse, the hyperbola, and the parabola. He added nothing to what Apollonius knew about the focal ratios, because that was only possible with the aid of the idea of infinity—a concept that no decent tactile-minded Greek had anything to do with. It is quite possible that when Pappus stated the three directrix-focus ratios he thought he had finished up the business of the conic sections and that nothing of importance remained to be done. The fact was that the subject had not yet been opened up and was not to be until after A.D. 1600, when it was taken up anew with ideas based on visual intuitions.

Now we must retrace our steps and take a glance at

[11] See Heath, *History of Greek Mathematics*, II, 119. Heath there has a heading which says that Euclid knew the focus-directrix property. This is based on a series of very tenuous inferences. If Euclid knew it, why should Apollonius, who knew Euclid's book, make no reference to so interesting and important a thing?

Euclid's famous book on Optics. The first definition tells us among other things that the lines of vision, or visual rays, are straight. The second is that the figure formed by the visual rays is a cone with its vertex in the eye, and its base on the contour of the objects seen. The fourth and seventh propositions are that, given equal segments of a line, the more distant appears the smaller. The sixth proposition is to the effect that parallel lines appear to approach each other.

The thirty-fourth and thirty-fifth propositions tell us, among other things, that if the line from the eye to the center of a circle is not perpendicular to the plane of the circle and is longer or shorter than the radius of the circle, then the diameters of the circle will not appear equal. Pappus, in the late third or early fourth century of the Christian era, i.e., six centuries or so after Euclid, in commenting on these two propositions (*Collections,* Book VI, proposition 53), proved that when the circle is seen from the position described by Euclid the apparent form of the circle is an ellipse, with its center not at the center of the circle but at another point, which he shows how to determine. Pappus also (proposition 54) solved the problem how, given a circle and a point within it, to find the point outside the plane of the circle from which the circle will appear to be an ellipse with its center at the given point. These two propositions of Pappus' are, so far as I have been able to discover, the closest that the Greek geometers came to the idea of central projection and section. It was a narrow miss, but a complete miss.[12]

[12] The stereographic projections described by Ptolemy (second century after Christ) in his Planisphaerium are merely circular subcontrary sections in which there are no metrical distortions of angles. In a way they correspond to the trick used by the photographer when he tilts both the negative and the easel in his enlarging machine in order to "correct" angular distortions.

When Pappus had finished, the situation was that the late Greek geometers knew two focal ratios, three directrix-focus ratios, and the visual transformation of a circle into an ellipse. They also knew, and these I shall come back to, not only particular cases of the invariance of anharmonic ratios but Euclid's "porism," the latter of which was as close a miss as possible for Desargues' Theorem. But they regarded these things as isolated propositions having no relation to each other. Had the late Greeks only added to them the one further idea that parallel lines meet at infinity,[13] they would have had in their hands at least logical equivalents of the basic ideas for geometrical continuity and for perspective and perspective geometry. This is to say that again and again during a period of six or seven centuries they went right up to the door of modern geometry, but that, inhibited by their tactile-muscular, metrical ideas, they were never able to open that door and pass out into the great open spaces of modern thought.

The story of Peithon and Serenus, two geometers of the fourth century of the Christian era, affords a striking example of how the Greeks missed out. As told by Heath[14] it is as follows:

"In the propositions (29-33) from this point to the end of the book Serenus deals with what is really an optical problem. It is introduced by a remark about a certain geometer, Peithon by name, who wrote a tract on the subject of parallels. Peithon, not being satisfied with

[13] The unhappiness of the Greeks over their inability to prove Euclid's postulate about parallel lines is well known (see R. Bonola, *Non-Euclidean Geometry*, Chicago, 1938, chap. i), but the most significant thing about this fact is that they made no attempt to evolve a geometry from which the postulate was lacking. This throws very important light upon their notions of "truth" and of the functions of postulates. Compare the quotations from Heath and F. A. Lange on pp. 54 and 55 *infra*.

[14] *History of Greek Mathematics*, II, 521.

Euclid's treatment of parallels, thought to define parallels by means of an illustration, observing that parallels are such lines as are shown on a wall or roof by the shadow of a pillar with a light behind it. This definition, it appears, was generally ridiculed; and Serenus seeks to rehabilitate Peithon, who was his friend, by showing that his statement is after all mathematically sound. He therefore proves, with regard to the cylinder, that, if any number of rays from a point outside the cylinder are drawn touching it on both sides, all the rays pass through the sides of a parallelogram (a section of the cylinder parallel to the axis)—Prop. 29—and if they are produced farther to meet any other plane parallel to that of the parallelogram the points in which they meet will lie on two parallel lines (Prop. 30); he adds that the lines will not *seem* parallel (*vide* Euclid's Optics, Prop. 6)."

Whatever else the story, as I have pieced it together, may tell, it brings out the fact that Greek art and Greek geometry were based on the same tactile-muscular sensuous intuitions, that in many ways their developments went along similar lines, and that their limitations were implicit in those intuitions.

I shall now attempt to point out how those intuitions gradually broke down and what happened after that. As I assume that there is a very general acquaintance with the characteristics of the art of the Gothic period and especially with those of the arts of the Renaissance and later times, I shall make but sparing references to them. Given the notion, the analogies should be obvious.

CHAPTER IV

FROM the GREEKS to the FIFTEENTH CENTURY

One of the least generally recognized but one of the most interesting things about the Greeks is the timing of their accomplishment. The early Greeks, whoever they were and whenever they began, were great travellers and they had available to them not only the remains of the earlier Minoan civilization but the living cultures of Egypt and Mesopotamia with their thousands of years of accumulated knowledge and techniques. It is impossible to think that they did not take advantage of these things. If we disregard Thales,[1] it may be assumed that Greek geometry began about 500 B.C. Thus it required only about two hundred years more before Euclid, in Egypt, had finished the task of compiling his Elements (i.e., about 300 B.C.). Within another hundred years

[1] It seems to be *de rigueur* to begin the history of geometry with Thales, about 600 B.C. The popularity of Euclid's great compilation caused the books of his predecessors to be forgotten, and so, aside from remarks by Proclus, a writer of the fifth century after Christ, very little is known about the early history of Greek geometry. As is well known, the Greeks had a charming habit of making up little stories about things they had forgotten. The fact that the one great history written by a Greek is frankly a "novelized" account has many

Archimedes, in Sicily, and Apollonius of Perga, working in Egypt, had made their contributions and the great imaginative work of the Greek geometers had for all practical purposes come to an end. It is important to notice that none of the three men just mentioned lived in Greece, that two of them worked in Egypt, and that all of them worked after the Alexandrian conquests which are customarily said to have put an end to the greatness of Greek thought. It is worth noting that we have no knowledge of what languages they spoke when

implications. Unlike our knowledge of Babylonian mathematics, which is based on original contemporary documents in which we can see that mathematics at work in the actual business of life and astronomy, our knowledge of Greek mathematics is based on manuscript textbooks, in which successive copyists and editors made many changes. The existing manuscripts of the important Greek mathematical texts are very late in date, few of them being earlier than the ninth century of the Christian era. Such knowledge as we have of Archimedes, for example, goes back to a single ninth-century manuscript that vanished in the sixteenth century. In O. Neugebauer's "History of Ancient Astronomy" (*Journal of Near Eastern Studies,* University of Chicago Press, IV, 18) it is said: "We find the basic relations between the chord and diameter of a circle already in use in Old Babylonian texts," i.e., of about 1700 B.C., "which employ the so-called 'Thales' and 'Pythagorean' theorems." Thus, it is likely that Thales and Pythagoras are no more than rather mythological personifications of the slight acquaintance that the Ionians of their time had acquired of the very much older Babylonian geometry. Ionia lay next to Lydia, and Lydia had close relations with Babylonia. It is also to be noted that the Babylonians of those early days had already developed an algebra of sorts and that they had two efficient numerical systems, the duodecimal and the decimal, both of which we still use. Above all they had a numerical "place value" notation. Unknown to the Greeks and Romans, this is basic to all our modern arithmetical calculation. Its importance has been compared to that of the alphabet. The Greek numerical system is today merely a cumbersome historical curiosity. For all I have seen, the idea of strict proof based on carefully stated premises, which has always been regarded as the hallmark of Greek geometry, makes its first indubitable appearance in the uncomfortable dialectic of Zeno in the fifth century B.C. According to Heath, the Greek philosophers thought that Zeno's "paradoxes" were fallacious, but the Greek mathematicians thought otherwise and thereafter discarded all attempts to use the idea of infinity. (See Heath, *History of Greek Mathematics,* I, 272.)

they were at home, or with what strange foreign accents they spoke the Greek that was their mathematical lingua franca. In any event these three productive centuries in mathematics were followed by a period of about seven and a quarter centuries (i.e., from the time of Apollonius about 200 B.C., to A.D. 529 when Justinian closed the doors of the Athenian Academy) during which little happened in Greek geometry beyond mopping up of detail.[2] If we may judge from the remarks of Heath, much of Greek geometry had been forgotten by the Greeks themselves prior to the third century after Christ. It was not until the first part of the seventeenth century that Archimedes and Apollonius had any worthy successors. These dates and periods mean very little to us unless we translate them into terms of our own history. The seven hundred and odd years during which the Greeks went to sleep in their geometry were a period comparable in length to that from the death of Richard Cœur de Lion in A.D. 1199 down to the present time. The period that elapsed between Apollonius and Desargues was about eighteen hundred years, a period as long as that from Hadrian or Marcus Aurelius to the present day.

Many reasons of many kinds have been alleged in explanation of (and even in apology for) these facts, but it seems to me that the most important reason for the failure of the Greeks to carry their geometry (and a number of other things) further during the long cen-

[2] Heath, who ignores Babylonian geometry and who accepts Thales, says, "With Apollonius the main body of Greek geometry is complete, and we may therefore fairly say that four centuries sufficed to complete it" (I, 3). Later he says, "With Archimedes and Apollonius Greek geometry reached its culminating point. There remained details to be filled in. . . . But, speaking generally, the further progress of geometry on general lines was practically barred by the restrictions of method and form which were inseparable from the classical Greek geometry. . . . Theoretical geometry being thus practically at the end of its resources, it was natural that mathematicians, seeking for an opening, should turn to the *applications* of geometry" (II, 197–198).

turies between Apollonius and Justinian is rarely mentioned.

In studying the past it is always necessary to remember the rôle and importance of symbolism in thought. What a people has no symbolism for, it can neither think about nor express. Thus, the extent to which a people's symbolism is generalized and abstract is the measure of its ability to think about more than the simplest things and relations. Ancient knowledge of a special or particular case, or even of a long series of them, is not the same as ancient knowledge of a general theorem or method. We must therefore take care in translating or explaining an ancient method or theorem to keep it within what were its limitations in its own time and place, and not to expand it to mean more than it actually did. The translation of old documents, not into their particular ungeneralized verbal equivalents in ordinary English, but into much broader "logical equivalents" in the highly generalized terminology of some modern science or discipline of thought, easily and frequently results in remarkable falsifications and distortions of the actual facts.

There can be no question about the curiosity, the intelligence, or the ingenuity of the Greeks. They loved to ask questions and to investigate, to speculate, to talk and to chop logic. They had an amazing command over the tricks of argumentation and they had no conscious inhibitions. They found out a great deal, but also they were often hampered and misled by their methods, which sometimes not only prevented them from thinking about things, but even, in the case of abstract notions, made it impossible for them to conceive of their existence. A few simple examples of this may not be amiss. It is best to take these examples from Greek geometry, not only because of its fame, but because it is a field in which the demonstrations involve no personal opinions or values.

As the Greeks had no algebraical symbols or methods they could only solve such equations as lent themselves to solution by Greek geometrical methods, which were restricted to lines, areas, and volumes, and in which three was the highest power or dimension. They discovered irrationals as incommensurable lines, e.g. the sides and diagonals of a square. They, therefore, represented irrationals as straight lines (as in Euclid's tenth book) and could only represent the product of two irrationals as a rectangle. They seem to have had little interest in the conic sections as geometry but a great deal of interest in them as a sort of *ersatz* for the algebra they did not have, —for they enabled them to solve certain equations not amenable to the ordinary geometry.[3] We have seen how the Greek method in conics prevented them from having any idea of geometrical continuity, and how their lack of a geometry of central projection and section prevented them from having any logical idea of a unified space.

It is quite possible that the greatest contribution made to civilization by the Greeks lay not in their art or the content of their thought but in the explicitly postulational approach and the development of deductional logic that accompanied their method of thought. Their geometry may be regarded as the abstract discipline in which these two things were most effectively worked out. However, powerful as is the deductional method of thought, it has its weak spots which have produced untold amounts of trouble and misunderstanding. One of these can be seen in the logical practice of the Greeks, who, when adopting the deductional method in their geometry did not accompany it by freedom of postulation. The true status of geometrical postulates was not recognized until comparatively recent times. For the Greeks and those who

[3] "The restriction then of the algebra employed by geometers to the geometrical form of algebra operated as an insuperable obstacle to any really new departure in theoretical geometry" (Heath, II, 198).

followed in their tradition the Euclidean axioms and postulates were final truths about space. They were neither assumptions arbitrarily adopted as bases for exercises in logic, nor, as applied in science and technology, hypotheses that could, from time to time, be altered "to save the appearances." This ties in with the historical unwillingness in practice to change basic postulates once a body of thought has been erected on them, and to cling to them long after it has become impossible to reconcile them with observed fact.[4] It is the things that are taken for granted that are hard to change, not the things that are deduced from them. In the course of time the things taken for granted become accepted as The Truth, and when that happens little less than a cataclysm is required before a change can be brought about. It may be that this is the meaning of "a culture."

I have met no more pregnant single sentences for an understanding of the causes which led to the *cul de sac* in which Greek geometry, and perhaps Greek thought in general, eventually wound up, than the following two. The first occurs in Heath's account of Antiphon's attempt to square the circle by a primitive method of exhaustion. "Aristotle roundly said that this was a fallacy which it was not even necessary for a geometer to trouble to refute, since an expert in any science is not called upon to refute *all* fallacies, but only those which are false deductions from the admitted principles of the science;

[4] To cite two cases in our own recent past: It is not improbable that much of the history of physics, from Hooke in the seventeenth century to the Michelson-Morley experiment of 1887 and Einstein's somewhat later relativity theory, may be summed up by saying that it was first the acceptance of the idea of an ether and then the hard struggle to get rid of it. For a long time men had greater faith in their assumption of an ether than in actual experiments and observations that were incompatible with it. Lalande in 1795 actually saw Neptune, but because it was not in accord with his theory he thought his observation erroneous. In 1846, Adams and Leverrier having worked out a theory, Neptune was "discovered."

if the fallacy is based on anything which is in contradiction to any of these principles, it may at once be ignored. (Arist. Phys. I. 2, 185a, 14–17.)"[5] The other sentence is that in which F. A. Lange, speaking of Aristotle's "inductive mounting from facts to principles," remarks, "At the most, what he does is to adduce a few isolated facts, and immediately spring from these to the most universal principles, to which he thenceforward dogmatically adheres in purely deductive treatment."[6] To the extent that Aristotle can be taken as representative of the Greek mind at work, these two sentences explain a great deal of what happened.

The basic postulates of Greek geometry were the tactile-muscular ones of congruence and parallelism. They not only made that geometry possible but set the limits beyond which it could not go. For practical purposes these limits were reached by Archimedes and Apollonius. Much the same thing happened in philosophy and art. During the vastly important period that elapsed between Aristotle in the fourth century B.C. and Plotinus in the second century of the Christian era, classical thought was dominated not by Plato but by various schools that originated in one or another form of philosophical scepticism. The Stoics, the most influential and powerful of these schools, so far from having any theory of art had little or no interest in art. No matter what its ethical principles, a materialistic philosophy directed at the cultivation of will power and the acquisition of the stiff upper lip is not calculated to produce either imaginative art or an understanding of it. At the end, Greek thought, following its own nature and methods, wound up hopeless in a blind alley of its own making.

The men of the "great period" when they created the

[5] Heath, I, 271.

[6] F. A. Lange, *The History of Materialism* (New York: Harcourt, Brace & Co., 1925), I, 88.

glory that was Greece fashioned it in such a way that it
was not only short but immediately and necessarily fol-
lowed by ages of exhaustion and sterility. This should not
be forgotten in any account of the Greek accomplish-
ment. The bankruptcy of the ancient world in the West,
and the loss in the West of such slight knowledge of
Greek culture, art, mathematics, and philosophy as it
had, may be regarded as the sort of catharsis that was
necessary to bring into existence another set of basic
postulates and to make possible new vision and new
thought.

In the last years of the Roman republic and the early
years of the empire there developed or came to light a
naturalism in the visual arts of a kind far removed from
anything that was specifically Greek. In the West it seems
to have been an indigenous character or trait. The
Roman artists made statements about the specific char-
acteristics of things as seen. In decoration the stone
cutters began to imitate natural plant forms in their
rinceaux. The portrait sculptors really told what manner
of men their sitters were. (Compare what Aristotle said
about the Greek portrait painters—Poetics, chap. 15,
1454b, 5-10.) The Augustan reliefs contain sharply
realized portrait groups of the imperial family. There
seems to have been a vague intuitive feeling or groping
for unified spaces.[7]

[7] See F. Wickhoff, *Roman Art* (London, 1900), and Alois Riegl,
Stilfragen (Berlin, 1893). Riegl brings out the Greek use of naturalistic,
but really abstract, forms, evolved on the drawing boards from the
motifs of other older peoples, e.g., the so-called acanthus, as contrasted
with the later use of natural forms taken from actual plants. The story
of the development of the rinceau, with its decorative use of natural
forms, is most suggestive. It was passed over as unimportant by the
earlier students, who were thinking in terms of the breakdown of the
ancient forms. With a change in point of view, it is seen to represent,
not merely a minor incident in the decline of a worn-out convention,
but the halting discovery of untried directions full of the most amazing
possibilities of growth and development.

The Greek mathematicians had ignored, but not answered, the criticisms of Zeno. The ancient philosophies provided no answers to the criticisms either of Zeno or of such sceptics as Carneades and Sextus Empiricus. They dismissed them as sophistries—forgetting that a sophistry is only a logical contradiction that you don't know how to resolve. But they had to be answered, and the only way they could be was by a change over to ideas and ideals of a wholly different kind.[8] During the second and third centuries after Christ in Rome there was a vast accession of disruptive and especially of mystical ideas from the East. Neo-Platonism and Christianity became powerful elements in thought and society. When Christianity finally took over it was shot through and through with Stoic and Neo-Platonic ideas. It provided for the first time a monotheistic God who, in addition to being jealous, had a capacity for both emotion and logic. Unlike the *ad hoc* god of the Greek philosophers, He was not merely a hypothetical answer to metaphysical difficulties, He was real and thus a cause of such difficulties. After the death of Julian, when this thinking creative God, Himself subject to the laws of thought, became the undisputed official God of the Empire, the ancient world was doomed. If we would understand the passing of the Greeks we must remember, among other things, the implications of the fact that they had many gods and no theology.

In the West not only were there repeated invasions from the North and a vast mixture of bloods and traditions, but shortly after A.D. 700 the Mohammedans overran North Africa and in a little time took over most of

[8] See Sextus Empiricus in the Loeb Library; A. P. McMahon, "Sextus Empiricus and the Arts," in *Harvard Studies in Classical Philology,* XLII (1931), 79; A. D. Nock, *Conversion* (Oxford University Press, 1933); F. Cumont, *Les Religions Orientales dans le Paganisme Romain* (Paris, 1929); W. R. Inge, *The Philosophy of Plotinus* (London: Longmans, Green, & Co., 1929); etc.

Spain. The speed and the extent of the Mohammedan conquest seem to indicate that it involved more than mere military power, and that perhaps in a way there had been an internal collapse of the crushing Greco-Roman system. The great repulse of the Muslim took place not in any of the lands subject to Byzantium, but, significantly, at Tours in France, in the battle fought in A.D. 732. The loss of the Mediterranean finally put an end to easy travel between the East and the West and to the steady importation of goods and knowledges from the Levant.[9] Among the things so lost was papyrus—the necessary writing material on which were based the administration of the Empire, the law, the publishing business, and easy interchange of correspondence.[10] Learning cannot exist without books and letters. Land travel was difficult and dangerous. The political breakdown brought with it insecurity and poverty. The gradual development of the Romance languages accompanied the settling down of the Western world into local particularisms and general ignorances. As it lost its dead weight of precedent the West was enabled to begin thinking for itself. Such contact as the West had with the East gave it knowledge not of Greek things but of Mohammedan and Byzantine things. Among the various results of all this was a cleavage between the words of the classical literary texts and the forms in which the classical peoples had clothed them in their visual arts. Virgil and Ovid continued to be read, but the ancient

[9] See Henri Pirenne, *Mohammed and Charlemagne* (New York, 1939), *passim,* but specially pp. 169 ff.

[10] See V. Gardthausen, *Das Buchwesen im Altertum und im Byzantischen Mittelalter* (Leipzig, 1911), pp. 162, 166, etc. Also W. Wattenbach, *Das Schriftwesen im Mittelalter* (Leipzig, 1896), *passim,* but specially pp. 100 ff. It is amusing to find Augustine apologizing to a friend for writing to him on parchment instead of on papyrus (Wattenbach, p. 101).

visual forms were lost.[11] The names and reputations of some of the ancient artists were known—but solely as a matter of verbal, literary tradition. What their work looked like the world had forgotten.

Moreover, Christianity, with its hatred of the old cults, myths, and idols, had come into the most complete power. Man was no longer the measure of all things. The new cosmology gradually provided a series of logically linked relationships that worked down into the very build of life and thought. Theoretically, at least, the world was highly and minutely organized. As Rashdall picturesquely put it, "The mysteries of logic were indeed intrinsically better calculated to fascinate the intellect of the half-civilized barbarian than the elegancies of classical poetry and oratory." [12] If mathematics, classical art, and most of classical literature dropped out, logic came in for its own. In the ninth century it fastened on the problem of universals,[13] a question explicitly raised but not answered in Boethius'

[11] See E. Panofsky, and F. Saxl, *Classical Mythology in Mediaeval Art* (Metropolitan Museum Studies, 1933), IV, 228. It is quite possible that the break with the classical forms, which began at least as early as the second century after Christ, was due not so much to ignorance of them as to weariness with them—that the West was fed up, bored to death, with the deadly monotony, the exhausted dullness of the inherited forms. See F. Lot, *The End of the Ancient World and the Beginnings of the Middle Ages* (London, 1931), pp. 147 ff. Much later, when fashion had again turned to the rediscovered classical forms, we find the echo of this in Leonardo da Vinci's heartfelt cry, "Let us not be dupes of the past" (Léonard da Vinci, *Textes Choisis* . . . , par Peladan, Paris, 1907, p. 71).

[12] Hastings Rashdall, *The Universities of Europe in the Middle Ages,* 2nd ed. (Oxford University Press, 1936), I, 37.

[13] As nearly as I can make out, the West's direct acquaintance with Greek thought prior to the twelfth century was at no time of more than the slightest importance; when the West did first develop its keen interest in Greek thought it was in that of Aristotle, whose logical teaching was of use to the realists in the discussions about universals that arose from the doctrine of the Eucharist; in spite of the West's later acquaintance with Plato and other Greek writers, the influence of Aristotle over the centuries has been the dominant one; Aristotelian-

sixth-century translation of Porphyry's third-century
Neo-Platonist introduction to Aristotle's Categories. The
Boethius became one of the great medieval textbooks.
The debate about nominalism and realism for centuries
absorbed the best intellect of Europe. Unlike anything
the Greeks had known, this was logic-chopping with a
vengeance and a divine sanction. The passage from
Porphyry is so interesting and so suggestive that it
should be quoted in any discussion of the difference be-
tween Classical art and that of the Middle Ages and
later periods. It is a direct challenge to the Greek ideas
of primary substance and attributable qualities.

What Porphyry-Boethius said was this: "Next, con-
cerning genera and species, the question indeed whether
they have a substantial existence, or whether they con-
sist in bare intellectual concepts only, or whether if
they have a substantial existence they are corporeal or
incorporeal, and whether they are separable from the
sensible properties of the things (or particulars of sense),
or are only in those properties and subsisting about them,
I shall forbear to determine. For a question of this kind
is a very deep one and one that requires a longer in-
vestigation." [14]

ism in the long run has been the principal obstacle in the path of
modern science and philosophy. The distinction commonly drawn be-
tween scholastic and renaissance thought has disguised the fact that
scholasticism was fully as much influenced by Greek ideas in one way
as renaissance thought was in another way. Of the two it is scholasti-
cism that not only has had the longer life but has played the more
important, even if obscurantist, rôle in European intellectual history
since the twelfth century. The teaching of art, archaeology, and litera-
ture abstracted from the philosophical background has, in this instance
at least, led to a very complete misunderstanding and misconception of
the places and ways in which Greek thought as a whole has been most
influential. To argue the matter in detail and cite authorities in support
of this point of view is impossible in a footnote.

[14] Quoted from Rashdall, *The Universities of Europe in the Middle
Ages,* I, 40.

The mere fact that opinion about such a matter could in the most literal, faggot, sense become a burning question indicates, or at least so it seems to me in my ignorance, not only that the western indigenous naturalism had become very important and stretched from the workshops of the artists to the studies of the theologians and philosophers, but that men had formed an ingrained habit both of imaginative logical thought and of facing its consequences. Logic coupled to a revealed religion becomes a very dangerous weapon. The real history of logic is not to be sought in the books on logic. There were few martyrs to thought in ancient Greece; the Early Christian and the Dark and Middle Ages in Europe were full of them. Somehow it ties in with the fact that slowly and gradually all sorts of new things, ideas, and interests were being discovered. Among these was the knowledge of stresses and strains that finally resulted alike in the architecture of the Gothic cathedrals and in the invention of horse collars. Up to the ninth or tenth century, heavy weights appear to have been pulled by men, in Greece, Rome and Byzantium as thousands of years before in Egypt. The discovery of how to utilize the strength of beasts had as momentous and unforeseeable results in the Middle Ages in the West as the discovery of how to utilize the strength of steam was to have in the nineteenth century.[15]

In the representational arts, for various reasons, not least of which was ecclesiastical disapproval, the shape

[15] For a short but remarkable survey of the many and important discoveries and inventions of the Middle Ages, see Lynn White, "Technology and Invention in the Middle Ages," *Speculum,* vol. XV (1940), in which it is said (p. 151): "Indeed, the technical skill of classical times was not simply maintained: it was considerably improved. Our view of history has been too toplofty. . . . In technology, at least, the Dark Ages mark a steady and uninterrupted advance over the Roman Empire." For the effect upon the Byzantine economy of the medieval East's failure to harness horses and oxen efficiently, see *The Cambridge Economic History* (Cambridge, 1942), I, 220.

of the naked human body early ceased to be an artistic preoccupation. Long before the medieval sculptors and painters had achieved realistic command over the shapes of clothed bodies, the indication of motion and gesture had become matter for serious study. The indigenous naturalism showed itself not so much in theoretical knowledge of general external anatomy as in sharply observed notation of particularities of personal character. In the middle of the twelfth century, Abbot Suger of St. Denis said, "The dull mind rises to truth by means of the sensible properties of things" (*Mens hebes ad verum per materialia surgit*).[16]

Across the centuries the religious subject matter of art gradually became dramatic. This drama was full of action. Action implied relationships between human figures located in the same visual spaces and not in different ones. The artists began to dislike action at a distance, much as later philosophers and physicists have disliked it.[17]

By the end of the thirteenth century this had begun to have the most positive effects in both painting and sculpture. The artists saw groups as dramatic wholes and not as spatially unorganized congeries of symbols. The Meditations on the Passion of the Franciscan Pseudo-Bonaventura gave alternative accounts of the episodes in the sacred story, but brought them all down as by eyewitness reports into the realm of the intimacies of actual life and actual emotion. The Dominican Golden Legend is filled with the heroism, the faith, the drama, the life, not only of the great but the small. The most

[16] Quoted by Emile Mâle in his *L'Art religieux du XII siècle en France* (Paris, 1922), p. 152, from Suger's *Liber de rebus in administratione sua gestis*.

[17] A clear instance is afforded by the development of the representation of the Nativity.

typical texts of their time, it would be difficult to find anything more fundamentally opposed to the ideas of the Greek philosophers.

Through the fourteenth century the endeavor towards this humanizing, this naturalizing, became more and more marked both in Italy and in the North.

CHAPTER V

ALBERTI

Early in the fifteenth century we find painters, such as Masaccio in Italy and the Van Eycks in the North, in whose work the feeling for solidity and for visually unified space is strongly marked. Masaccio died in 1428, and the younger Van Eyck in 1440. It seems reasonable to think that the possibility of a rational theory of perspective had by this time been canvassed in the studios of the artists, even if not in the studies of the mathematicians and philosophers. In any event, in 1435, roughly halfway between the deaths of Masaccio and Van Eyck, the young Leone Battista Alberti wrote a little book on painting in Latin. The next year he rewrote it in Italian and dedicated it to Brunelleschi.[1] For more than one reason it was the most interesting and the most influential of all the early Renaissance treatises on art.

In at least two ways Alberti's essay on painting, which is usually referred to as the *della Pittura,* sounded the reveille of modern times and modern thought. One of these was his explicit assumption that picture-making meant the depiction of human figures in action and

[1] See L. B. Alberti, *Kleinere Kunsttheoretische Schriften* (edited by H. Janitscheck), in *Quellenschriften für Kunstgeschichte* (Vienna, 1877).

with movements and gestures corresponding to psychological and emotional states. In one place Alberti refers to "we painters who wish to show the movements of the soul by means of the movements of the limbs." A few lines before this he says, "It is, therefore, necessary that painters should have command over all the movements of the body, which they will learn well from nature, in order to imitate the many movements of the soul, even though this is difficult. Who, without trying it, would believe how difficult it is to depict a laughing face without making it appear sorrowful rather than joyous? And, in the same way, who, without much study, can draw faces in which the chin, eyes, cheeks, and forehead, all unite in laughing or weeping at the same time? To do this it is necessary to learn from nature and always to seek after the most fugitive aspects of things and those which make him who perceives them think about more than he sees." [2]

The basic contrast between this and the Greek idea of thinking about less than is seen is obvious. Professor Butcher sums up the latter by saying, "If we may expand Aristotle's idea in the light of his own system,—fine art eliminates what is transient and particular and reveals the permanent and essential features of the original." [3]

[2] These two quotations are so important that it is well to repeat them in the original. "Ma noi dipintori i quali volliamo coi movimenti delle membra mostrare i movimenti dell'animo, . . ." (Alberti, *loc cit.*, p. 125). "Cosi adunque conviene, sieno ai pictori notissimi tutti i movimenti del corpo quali bene impareranno dalla natura, bene che sia cosa difficile imitare i molti movimenti dello animo. Et chi mai credesse, se non provando, tanto essere difficile volendo depigniere uno viso che rida, schifare di non lo fare piu tosto piangioso che lieto? et ancora chi mai potesse senza grandissimo studio exprimere visi nel quale la bocca, il mento, li occhi, le guance, il fronte, i cigli tutti ad uno ridere o piangere convengono. Per questo molto conviensi impararli dalla natura et sempre seguire cose molto prompte et quali lassino a chi le guarda molto più che elli nonvedi." (*Ibid.*, p. 122.)

[3] Butcher, *Aristotle's Theory of Poetry and Fine Art*, p. 150. I have strong suspicion that the idea of "fine art" has been read into Aristotle

It is interesting to notice how this Aristotelian distinction between the permanent (primary qualities) and the transient (secondary qualities) runs like a *leit motif* through much of the modern discussion and explanation of Greek art. In spite of the fact that the Three Dialogues between Hylas and Philonous were published in 1713, we are still solemnly told that the Greek artists did in fact bring out the permanent and essential and eliminate the transient and particular and in this way produced the peculiar and ideal quality of their art. When Berkeley showed that the distinction between the primary and the secondary qualities is fallacious he did more than knock out one of the cardinal tenets of Greek philosophy, for he, incidentally and quite unconsciously, reduced to nonsense any theory of art based on that distinction and any insight that it might be thought to afford into the inner being of Greek or any other art.

The ancient Greeks apparently made no opposition or distinction between imagination and imitation in the representational arts.[4] What are seemingly the first in-

by Butcher. If we eliminate the word "fine" and its connotations from this quotation, I imagine that it may well be an adequate statement of the Aristotelian point of view.

[4] In several of his dialogues Plato's characters talk about art and artists, but I doubt that he ever had the idea of what we call imagination. Perhaps he came as close to it as anywhere in the little known *Ion*, where he shows us a pompous art specialist (rhapsode) being taken for a ride by Socrates. Ion, the specialist, proclaims one artist (Homer) to be the greatest of all and claims to know all about his work, while at the same time admitting his own dense ignorance of the work of all other artists. Socrates, with witty malice, drives Ion into a corner where he has to choose between being thought dishonest or irresponsible (inspired). The comedy is an unsafe basis for any theory except that Plato had a keen sense of humor and enjoyed showing up a rather common failing of people who talk about art. Jowett uses the word imagination in *Sophist*, 264, but F. M. Cornford (*Plato's Theory of Knowledge*, New York, 1935) does not. If one who knows no Greek

stances of such a distinction occur in the life of Apol-
lonius of Tyana (vi, 19) by Philostratus, who seems to
have written about A.D. 210, and in Plotinus (204–270).
Dean Inge, expounding Plotinus, says: "The true artist
does not copy nature. Here he [i.e., Plotinus] agrees
with Philostratus, who in an epoch-making passage
says that great works of art are produced not by imita-
tion (the Aristotelian μίμησις), but by imagination
(φαντασία), 'a wiser creator than imitation; for imita-
tion copies what it has seen, imagination what it has not
seen.'" Bernard Bosanquet cites the anecdote in which
this remark is made and says of it, " . . . in the biography
of Apollonius, the antithesis of imitation and imagina-
tion as two co-ordinate principles of art is stated with
the full consciousness of its novelty and importance."[5]

Thus, I wonder if anything much less Greek can be
imagined than Alberti's "We painters who wish to show
the movements of the soul by the movements of the
limbs," and "always to seek after the most fugitive as-
pects of things and those which make him who perceives
them think about more than he sees." It may be regarded
as the practical summation of the long habit of Medieval
thought. In its so-different way, it was a repetition of the
questioning challenge that a thousand and more years
earlier Porphyry, the Neo-Platonist, had given to the
Platonic and Aristotelian doctrines of substance and
quality. It cuts deep under mere mimesis and admits both
creative and symbolic values. The history of art during
the five hundred years that have elapsed since Alberti
wrote has been little more than the story of the slow

may have an opinion on such a matter, Cornford's translation makes
better sense than Jowett's. Aristotle, De Anima, III, 3, also uses φαντασία
but in still another meaning than Plato's.

[5] See W. R. Inge, The Philosophy of Plotinus, II, 216; B. Bosanquet,
A History of Aesthetic (London: Swan Sonnenschein & Co., Ltd.,
1904), p. 109; and Butcher, op. cit., pp. 126 ff.

diffusion of his ideas through the artists and peoples of Europe.[6]

The other thing in Alberti's book that marked the coming of a new attitude far removed from that of the Greeks was his description of the earliest known geometrical scheme for depicting objects in a unified space, or in other words what we today call perspective. Just as it was a major event in the history of pictorial representation, so it was in the history of geometry, for in it was stated for the first time the now familiar process of central projection and section,[7] the subsequent development of which has been the outstanding feature of modern synthetic geometry. It is an idea that was unknown to the Greeks, and it was discovered at a time so ignorant of geometry that Alberti thought it necessary to explain the words diameter and perpendicular.

As much of the subsequent history of physics and philosophy, as well as of picture making and geometry,

[6] As compared with the changes in technology and in the subjects and methods of thought brought about during the Dark and Middle Ages, the results of the much vaunted rediscovery of classical forms by the Renaissance have amounted to little more than fashions in superficial decoration, doubtless of more "importance" but basically of the same order as the more fleeting fashions for "turquerie" and "chinoiserie." Donatello, Michelangelo, and Bernini were as antithetical to the classical thing as any medieval sculptor. There is much to think about in the fact that St. Paul's in London, although designed towards the end of the seventeenth century by a man who had been Savilian Professor of Astronomy at Oxford and was a mathematician respected by Newton, has the plan and the structure, even to the flying buttresses, of a medieval cathedral. The structure and design of the dome and lantern are completely new. The Greek architectural forms so far as used have become merely applied decoration. The cathedral of Ste. Croix at Orléans is interesting for the same general reasons.

[7] Central projection and section is perhaps most familiar to us as the principle on which magic lanterns and cameras work—of projecting a picture or view onto a screen or film. I regret that in footnote 9, p. 10, of my book On the Rationalization of Sight (New York, 1938), I stated that "the late Greek geometers on rare occasion utilized this procedure." The instance there cited is of orthogonal and not of central projection.

is centered about the idea or problem of space, it is interesting and important to trace the development of perspective from its discovery or invention as a quasi-mechanical procedure to a logical scheme or grammar of thought.

CHAPTER VI

FIFTEENTH and SIXTEENTH CENTURY PERSPECTIVE

The *Vita Anonyma* of Alberti tells us that he "brought about things unheard of and that the spectators found unbelievable, and he showed these things through a tiny opening that was made in a little closed box. . . . He called these things 'demonstrations,' and they were of such a kind that both artists and laymen questioned whether they saw painted things or natural things themselves." [1] Analysis of his own difficult text brings out the rest of the story.[2]

Alberti attacked his perspective problem from a strictly practical point of view. His genius showed itself first in the extreme simplicity of the form to which he reduced his problem, which was how to determine the shape and measurements of the picture or visual image of a square of known size when it lay on the ground at a known distance from the beholder. That genius showed itself again in the choice of a tessellated pavement or checkerboard as the object with which to con-

[1] Alberti, *Kleinere Kunsttheoretische Schriften*, p. 229.

[2] A detailed examination of the texts on perspective of Alberti, Pelerin, and Dürer, will be found in W. M. Ivins, jr., *On the Rationalization of Sight* (New York, 1938).

duct his experiments, for its cross lines were regular coördinates which made it easy to plot any shape superimposed upon it.

Remembering that no one had done anything like it, Alberti's method and construction are as ingenious as they are simple. In all Greek geometry there is nothing more fundamental and nothing that opened the way to such great generalization. The basic idea of it is that when a man sees something through a window he can get a correct image of it by tracing its outlines on the window pane, provided that while he does this he uses only one eye and does not move his head. Alberti's construction is no more than a graphic way of reducing this process to a series of interrelated measurements. Without being aware of it, what Alberti was doing was a sort of practical combination of Apollonius' conic sections and Pappus' optical theorem about the appearance of a circle from a given position outside the plane of the circle, with the one important difference that he was interested not in the circle or its appearance but in the appearance of a pattern, e.g. his checkerboard, within the circle. No ancient Greek seems ever to have perceived that this presented a problem of interest.

As nearly as I have been able to discover, Alberti's procedure—if not in actual manipulation at least in thought—was something like this: He took an oblong box that was long enough for his purpose and removed the top, one end, and one side. In the middle of the remaining end and towards its top he bored an eye or peep hole. On the bottom at the other end he laid a checkerboard just the width of the bottom. When he looked through the eye hole at the checkerboard, he saw that it took the shape of a cross section of a truncated cone. Realizing that the answer to his problem of its apparent height and the apparent comparative lengths of its top and bottom lay in the relationship between the

lines of his vision, the eye hole, and the checkerboard, he made a model of the lines of his vision by stretching strings from the eye hole to the corners of the squares on the checkerboard. This enabled him to get out from behind his lines of vision and study them from various positions.

When he did this he realized that the correct picture of the checkerboard was no other than what we today would call the projection of the checkerboard on a plane that intersected his lines of vision, and that its size, shape, and position on that plane would depend on the location of the plane between the eye hole and the checkerboard. So far as appears to be known, no one before him had realized this simple fact. To get the needed information all that was required was to settle a position for the picture plane and take measurements of the places at which the lines of vision ran through it. To do this with a foot rule would have been possible, but difficult, laborious, and impractical. What was needed was a graphic method.

Therefore, Alberti, taking a trick from the carpenters and stone cutters, had recourse to a templet, i.e., a thin piece of board cut out at one end or side until it just fits a contour or molding. He took a board of the same width as his checkerboard, with square ends and parallel sides, cut away one end in the shape of an inverted Roman capital V, wide enough for its lower corners to straddle the checkerboard and high enough for it to come up to the eye hole in the end of the box. He could place this over the strings or lines of vision at any position he wished, but for present purposes I shall presume that he placed it so that its two corners met the two corners of the checkerboard nearest the eye hole. With the templet in this position he marked on it the heights at which the rows of strings passed through it. This done he moved to the end opposite the eye hole, and there made

a measured drawing of what he saw. This drawing showed the bottom of the box, the outer edge of the templet, the strings representing the lines of vision as they ran from the checkerboard to the eye hole, and the cross lines on the templet at the heights at which the strings ran through it. Then, shifting his position to the side of the model, he made another measured drawing, to the same scale, of what he saw, indicating on it the bottom and end of the box, the eye hole at its proper height above the bottom, the lines of vision and the places where they met the checkerboard, and at the side of the checkerboard a perpendicular line to represent the outside edge of his templet. He then, and this was the supreme test of his genius, superimposed his two drawings in such a way that the lines in them which represented the bottom and the outer edge of his templet coincided. He drew the cross lines on the templet across the lines representing the strings. Then, to make sure that the two drawings were to the same scale, he drew a diagonal line from the intersection of the top cross line on the templet with the outer string to the opposite bottom corner of the inverted bundle of strings. If this diagonal line passed through the intersections of the lines representing the strings and the extended lines across his templet, it proved that his two drawings were to the same scale. The completed drawing was neither more nor less than the very simple schematic diagram familiar to all students of old perspective as the Italian Renaissance *costruzione legittima*. Instead of being the result of very abstruse and abstract geometrical reasoning it was quite as simple and ingenious as anything that an intelligent carpenter might do.

It is interesting and important to notice that the combined drawing contains two different views of the strings representing the lines of sight and two different views of the eye hole. Alberti called the eye hole of his

first drawing the center point, the eye hole of the other drawing he called his eye. Both Leonardo da Vinci and Dürer when drawing the construction put literal eyes at each of the two points. Dürer, in his description of the construction, called the center point his "near eye" and the other point his "other eye." In modern terminology the "center point" or "near eye" is the "vanishing point," and the "eye" or "other eye" is the "distance point."

Alberti's construction was embodied in the combined drawing shown here. A, the distance point, represents

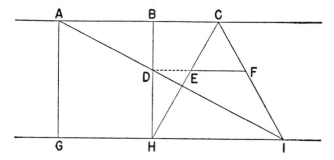

the eye in one of the two preliminary drawings. C, the center point, represents it in the other. AG is the height of the eye above the plane in which the checkerboard lies. The lines AC and GI are parallel. AB equals GH, which equals the distance to the near edge of the checkerboard. AG and BH are perpendicular to GI. HI is the length of the edge of the square checkerboard. DF is parallel to GI. HE and IF are the sides of the square checkerboard as seen from C. The quadrilateral HEFI is the checkerboard as seen by the eye. If the drawing is made to scale, the measurements of the appearance of the foreshortened checkerboard in the plane represented by BH can be taken from the drawing. Normally C lies above the center of HI, but there is no geometrical reason for it to be in any particular place so long as it lies on the line AB.

Alberti did not call explicit attention to the measure-
ments in his construction, but its implicit mensurational
aspects were obvious. A drawing of the construction in
one of Leonardo's notebooks is accompanied by a short
explanation of them.[3] The step from the shape of a
checkerboard seen in perspective to that of three-dimen-
sional objects seen in perspective was a simple problem
that required but little ingenuity.

The next important text on the subject was that pub-
lished at Toul in France in 1505 by Pelerin, which is
known after him as the Viator.[4] I believe that Pelerin,
like Alberti before him, worked out his solution from a
model, and that his operation resembled that of Alberti
in all but one very small detail. It is possible, however,
that he worked it out from Alberti's scheme as a simple
problem in elementary plane geometry. In any event
Pelerin's construction, which is known as the distance
point construction, is a simplified geometrical equivalent
of that of Alberti.[5] Pelerin's construction is still in cur-
rent use in the schools.

It has been said that Alberti's greatest discovery was
that the picture plane was a section of the cone of vision,
but really it was something in addition to that. Up to his
time the problem had been thought of as a simple two-

[3] See the facsimile given by C. Ravaisson-Mollien in *Les Manuscrits
de Léonard da Vinci: Le Manuscrit A de la Bibliothèque de l'Institut*
(Paris, 1881), fol. 42 recto. A reproduction appears in Ivins, *On the
Rationalization of Sight*, p. 23.

[4] *Viator, De Artificiali Perspectiva* (Toul: Petrus Jacobi, 1505). The
essential diagrams and the French text are reproduced in Ivins, *On the
Rationalization of Sight*.

Piero della Francesca, when aged and blind, dictated a book on
perspective that, thanks to Vasari's reference to it, has achieved a
certain fame. I do not know what circulation or influence it had. In any
event it was not geometrically sound and it was first printed in 1899.
See C. Winterberg, *Petrus Pictor Burgensis de Prospectiva pingendi* . . .
(Strassburg, 1899).

[5] In simplified form Pelerin's construction is as follows, the lettering

term, beholder–object relation that really was insoluble. His great contribution, though doubtless he was not aware of it, was that in fact he discarded the simple two-term relation and discovered other relations sufficient in number to permit of solution—in other words he discovered that form and position were functions of each other and thus were relative and not absolute, and that no two-dimensional statement of form and position in three-dimensional space could be made in anything short of a four- or five-term relation. Simple as his construction was, it was full of implicit mathematical and philosophical ideas of the greatest importance.

After Pelerin, Dürer was for long the best known writer on perspective. His book was published in 1525, and again, with slight changes, in 1538.[6] During much of the sixteenth century it was probably the most popular text on its subject, and was translated into several different languages. Dürer was acquainted with the constructions of both Alberti and Pelerin, but he never really understood either of them. The importance of

corresponding to that in the figure of Alberti's construction on p. 74.

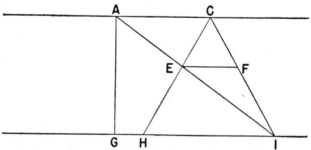

Alberti's perpendicular from H is omitted, and the distance to the near edge of the checkerboard is the distance AC (and not GH). The triangle CHI is isosceles. Dürer's failure to realize that it was not scalene was the source of many of his curious perspective distortions.

[6] Albrecht Dürer, *Underweysung der messung.* . . . (Nueremberg, 1525, 1538.)

Dürer's text is to be sought not in any contribution that he made to the theory of perspective but in the way he misled many people for several generations. The effect of his misunderstanding is clearly visible in much of his own work. It came close to being a systematic denial of the homogeneity of space. Interesting as this is, it is aside from the point of the present inquiry.[7]

The first important student of perspective after Dürer was the great architect Vignola, who taught at Rome in the 1530's. His teaching was not brought together in book form until 1583, when Ignazio Danti published it under the title *Le Due Regole della Prospettiva Pratica.*[8] Vignola appears to have been the first to teach both the *costruzione legittima* of Alberti and the distance-point construction of Pelerin and to make it clear that the two had identical results. It was seemingly not until Danti's book came out in 1583 that this fact appeared in print.[9] That Vignola, one of the designers of St. Peter's and the architect of the Gesù in Rome, should have been one of the great masters of theoretical perspective throws much light upon the spatial origins and character of the Baroque.

[7] For a detailed analysis of Dürer's procedure and its effect in certain odd qualities of his work, see Ivins, *On the Rationalization of Sight.*

[8] *Le Due Regole della Prospettiva Pratica di M. Iacomo Barozzi da Vignola con i comentarii del R.P.M. Ignazio Danti . . . In Roma per Francesco Zannetti MDLXXXIII. . . .*

[9] The following diagram, reproduced from p. 18 of the *Due Regole,* shows that the two constructions have identical results:

Between Dürer's book of 1525 and Vignola-Danti's of 1583 there were many others, none of which seems to have made any important addition to the theory and many of which got the matter sadly tangled. Finally, in 1600, Guidobaldo del Monte published his book,[10] which was a summary of all that was known about perspective at that time. With its aid the Baroque was promptly in full swing.

[10] *Guidibaldi e Marchionibus Montis Perspectivae Libri Sex, Pisauri. Apud Hieronymum Concordiam, M.DC. . . .*

CHAPTER VII

CUSANUS and KEPLER

The next step in the history of the idea of a unified space and its representation takes us over to theology, to astronomy, and to the mystical borders of astrology. For the first time men were to have the temerity to use ideas that contradicted the Greek intuitional postulate of parallelism, and to break through and across the Greek logic of watertight categories and discontinuities. Aristotle would have dismissed these ideas as fallacies of the sort that were not to be refuted but to be ignored.[1]

In 1440 Cusanus, i.e., Nicholas of Cusa, finished his *De Docta Ignorantia,* in which, incidentally to his theological interest and argument, he produced not only a theory of epistemological relativity but a doctrine which he illustrated by examples of the "union of extremes through transitions and middle terms, and of their comprehension by means of the continuity thus effected."[2] Among other corollaries or results of these two basic ideas he adduced the relativity of determinations of place and motion and the idea that "Every figure, without deviation from the rules of its construction, can be made by continuous modifications to come nearer and nearer to coincidence with figures of which the rules of

[1] Compare Aristotle's *Physics,* 185a.15.

[2] See H. Höffding, *A History of Modern Philosophy* (London, Macmillan & Co., 1908), Bk. I, chap. x, which is devoted to Cusanus, p. 87.

construction are different. For example, the larger you make the circumference of a circle, the nearer an arc of it is to a straight line; the arc, therefore, of a circle than which there can be no greater will be actually a straight line. If supposed infinite, then, the curve and the straight line coincide." [3]

To us of today, these and many more of Cusanus' ideas seem familiar enough, but at the time when he put them forth little could have been more revolutionary or more at variance with accepted philosophical, scientific, and religious notions. His principal philosophical ideas seem to have been followed up by his great successor, Giordano Bruno, who in 1600 paid the penalty for his thought. The Church translated Aristotle's "to be ignored" as meaning to be burnt alive.

The first great practical application of Cusanus' philosophical ideas to mathematics came in 1604, when Kepler, the astronomer, published his *Ad Vitellionem Paralipomena*, a supplement or commentary on Witelo's thirteenth-century book on optics and catoptrics, which in its turn had been based on an Arabic commentary on Euclid's books on those subjects. The Witelo was a standard textbook in the medieval universities, and, at Oxford at least, could take the place of Euclid in the curriculum.[4] A chapter in the *Ad Vitellionem* dealt with the conic sections and contained in a few short pages a statement that was the stuff that real history is made of.[5] As an account of what is probably one of the greatest reaches of imagination in all the long history of mathematics, it must be dealt with at some length, not only

[3] T. Whittaker, "Nicholas of Cusa," *Mind*, N.S., XXXIV, 443.

[4] Rashdall, *The Universities of Europe in the Middle Ages*, III, 155.

[5] A line-for-line reprint of the important passage, with a commentary, is given in "The Geometry of Kepler and Newton," by Dr. C. Taylor, in the *Transactions of the Cambridge Philosophical Society*, XVIII (1900), 197.

for its own interest as showing the imagination at work, but for its geometrical content.

Kepler had been Tycho Brahe's assistant, and after his death had inherited the long series of observations that he had made of the planets. From these Kepler came to the conclusion that the orbits of the planets were ellipses and not circles (or, rather, epicycles) as every one had thought from at least the time of Ptolemy in the second century of the Christian era.

This was ample reason for Kepler to turn his attention to the conic sections. His account of them, beginning with a description of the several kinds of cones, proceeds to a statement of the results of his investigation. At the end he describes "pin and string" methods for drawing first the hyperbola, then the ellipse—which were easy, and finally the parabola, which he says cost him time and trouble (*diu dolui*) before he could work it out. This confession of difficulty, coming just where it does in the story, leads me to believe that Kepler's experiments with pins and string (whether actual or conceptual) preceded his discoveries and led up to them— for it was the parabola that provided the crux in his theory. It was not until he had finally succeeded in fastening the parabola to the hyperbola and the ellipse with pins and string that he had the sections in an unbroken continuous sequence. In any event, I shall tell the story as though that were the order in which he worked.

Up to Kepler's time, apparently, no need for the conic sections had arisen in specifically geometrical practice. Once that need was discovered, it became highly desirable to devise some simple graphic method of constructing the various curves. Kepler solved this problem by using two pins on his drawing board to represent the foci of the ellipse and the hyperbola, and, tied to them and looped about his pencil, a string or strings to

represent the distances from them. The method is now familiar.[6]

Kepler noticed in drawing his hyperbola that the further his pins were from each other the more his curves resembled parabolas, and that the closer his pins were to each other the more closely his curves approached his asymptotes, i.e., the cross lines that represented the sides of the cone. If the pins were to coincide they would lie on the intersection of those cross lines and the curve would be the cross lines. In drawing his ellipse he noticed that the further apart his pins were the more closely the ends of his curve resembled parabolas and the more closely the sides of his ellipse resembled parallel lines. The closer together he put his pins the more obtuse his ellipse became, until when the pins coincided the ellipse became a circle.

He now had a series of conic sections that, starting at one end, so to speak, with a pair of cross straight lines, passed through an infinity of hyperbolas the curves of which more and more closely resembled parabolas. Starting at the other end with a circle, he had an infinite series of ellipses, which also more and more closely resembled parabolas. This intimated that the parabola partook of the natures of both the hyperbola and the ellipse, and therefore should resemble both. So far Kepler's problem had been easy, but now it became difficult.

The old Greeks had said nothing about the foci of

[6] The use of strings to draw ellipses and hyperbolas is based on the facts that the sum of the distances from any point on the ellipse to the two foci is a constant and that the difference between the distances from any point on one branch of a hyperbola to the two foci is a constant. The earliest use of strings to draw an ellipse to which I have found reference is in the book of Anthemius, an architect of Sancta Sophia at Constantinople, who died about A.D. 534 (see Heath, *History of Greek Mathematics,* II, 542). For all I have noticed, Kepler was the first to draw either a hyperbola or a parabola with strings.

the parabola. In fact, they had no name for the focus of any conic. Anthemius, in the sixth century, however, had proved that parallel rays are reflected to one single point from a parabolic mirror.[7] Witelo, whose book Kepler was commenting upon, knew, presumably from some Arabic author who knew or rediscovered Anthemius' theorem, that the rays of the sun when reflected from a parabolic or burning mirror converged at a point which was known as the burning point, i.e., the focus, or *foyer*, or *Brennpunkt*, depending on which language you were using. It was undoubtedly his knowledge of these things that made it possible for Kepler to draw a parabola with a loop of string.

He drew a line for his axis. On this he inserted a pin. At one side of the pin he drew a transverse line that intersected the axis at right angles. On the other side of the pin he made a mark on his axis to serve as the apex of his parabola. He tied a string to the pin, put the point of his pencil on the apex, passed the string about it and pulled the string back taut to the intersection of the axis and the transverse line. There he tied a knot in the string. Then, as with one hand he swung his pencil around in the loop, with the other hand he moved the knot along the transverse line so that the string between the knot and the pencil was always parallel to the axis. The line made by the pencil point in this way was a parabola.[8]

However, although he had found an easy way of drawing a parabola, he had also stumbled into an even more difficult problem. He had made his parabola with only one pin or focus. But, if the parabola really partook

[7] Heath, II, 541.

[8] Kepler's one-string method gave him a parabola as ellipse. The parabola as hyperbola can be drawn with two strings, just as the hyperbola is, but it requires the use of a straight-edge, a moving T-square, and eyelets for the strings to pass through. In this case the transverse line is on the other or closed side of the curve.

of the natures of both the ellipse and the hyperbola, then it should have two foci just as they did. There was only one place the missing focus could possibly be, and that was somewhere on the axis. However, the missing focus had to be both within the curve to correspond to the second focus of the ellipse and without the curve to correspond to the second focus of the hyperbola, that is, it had to be reached in either direction along the axis. Unless he was acquainted with Nicholas of Cusa's philosophical theory, it probably took a long time before the answer to this contradiction entered his head. Had he been a hard-headed Greek it probably would never have occurred to him, but he was not a Greek of any kind, he was a serious Teuton, who made serious money casting serious horoscopes for serious people like Wallenstein and the Emperor. The only possible answer was that the axis was both a circle and a straight line. Then it occurred to him that a circle with a radius that was infinitely long would itself be a straight line, and that this was what his axis was. With this he had the answer to the question about the locus of the missing focus of the parabola—it had to be on the axis and it could not be at a finite distance, because then it would produce either an ellipse or a hyperbola, *ergo* it must be at infinity. Kepler knew that as the point of intersection of two straight lines, each anchored to an immovable point as a pivot, was moved further and further away, the two lines more closely approached being parallel. And so why not say that when the point of intersection got infinitely distant the intersecting lines actually had become parallel? It is the kind of thing that is constantly done in the mathematics of practical measurements as distinct from the mathematics of pure logical theory. This made it possible to say that a line from the infinitely distant focus to any point on the parabola was parallel to the axis. Admitting that from some points of view

these things were rather absurd; still they provided
very interesting analogies—and, especially, they ex-
plained that inconveniently parallel line.[9]
Anyway, these things put Kepler in possession of
several notions that no one before him—even if, like
Nicholas of Cusa, he had thought of some of them—had
ever had the courage to apply in public to a practical
geometrical problem: that a straight line extended in
either direction until its ends met; that the ends met at
infinity; that they met in just one point; that there were
five conic sections; and that tucked in between the limit-
ing cases of the line pair, the parabola, and the circle,
which were always the same, there were infinite series
of hyperbolas and ellipses which infinitely approached
the forms lying either side of them and finally merged
in them, so that there was no break in the continuity
of evolving form between the line pair and the circle.
It was undoubtedly mystical business, but it pulled to-
gether in a close-knit pattern of analogical similarity a
group of things that otherwise were separate and un-
related. So far as seems to be known, it was the first
geometrical, as distinct from philosophical, formulation
of the doctrine of continuity. It was an idea the like of
which cannot be found in Greek mathematics.

The general assumption that parallel lines meet had
been implicit in Alberti's 1435 scheme of projection and
section, but no one had seen it there, in spite of Alberti's
statement that his construction showed him how the

[9] At the end of his technical description of the conics and just at the
beginning of his account of his pin-and-string methods, Kepler says:
"Oportet enim nobis servire voces Geometricas analogiae: plurimum
namque amo analogias, fidelissimos meos magistros, omnium naturae
arcanorum conscios: in Geometria praecipue suspiciendos, dum in-
finitos casus interiectos intra sua extrema, mediumque, quantumuis
absurdis locutionibus concludunt, totamque rei alicuius essentiam
luculenter ponunt ob oculos. Quin etiam in descriptione sectionum
analogia plurimum me iuuit." (Taylor, loc. cit., p. 200.)

transverse parallel lines on his checkerboard appeared to change in length as they got further and further away towards infinity—"quasi persino in infinito." [10] I do not know whether or not Kepler was familiar with Alberti's text, but if he were there is a possibility, a bare possibility, that that phrase "quasi persino in infinito" may have been the little thing that gave him the hint he needed. However, the conic sections of the Greeks and the Albertian perspective of the Italian artists were so different in their uses and their students that there is little reason to think that any one saw their basic resemblances.

[10] Alberti, *op. cit.*, p. 81.

CHAPTER VIII

DESARGUES and PASCAL

The first person, apparently, to see that the old conic
sections and the new perspective had business in com-
mon was Girard Desargues, a friend of Descartes,
Fermat, and Pascal.[1] He was an engineer and architect
and seems to have had the idea that it might be possible
to find some way of generalizing into simple compact
form the very large number of disparate geometrical
theorems that artists, engineers, and stonecutters had
to know in order to practice their professions. From
things said by Descartes and by Bosse, Desargues's
pupil, there is reason to think that Desargues deliber-
ately adopted a vocabulary different from that of other
geometers in the hope that his theories might thus be
made easier for craftsmen and artists to understand. Its
principal effect, however, was to make everything much
more difficult for everyone—the result that usually ac-
companies attempts to make difficult things easy.

There seems to be no clue to the origin and history
of his thought. In his texts he mentions Ptolemy, Euclid,

[1] For practical purposes the *Œuvres de Desargues réunies et analysées
par M. Poudra* (Paris, 1864) contains all of Desargues' known work
and all that is known about him. Poudra's proofreading was careless,
and his analyses are not always to be trusted, but our debt to him is
very great.

and Apollonius. Bits of his strange vocabulary bear such close resemblance to some of the odd terms used by Alberti that it is not improbable he had read his essay on painting.[2] He was certainly familiar with the later books on perspective. There were available to him only the first four books of Apollonius, the rest not yet having been printed or translated from the Arabic. Whether or not he was familiar with Kepler's little chapter on the conic sections or with the Seventh Book of Pappus, whose *Collections* had been published in Latin in 1589, seems not to be known, though he may easily have read them. His opponents jeered at him as a self-educated man. He himself claimed that he worked out his ideas for himself, and his friend Fermat said the same thing about him in a letter to Mersenne.[3] The fact that at one place [4] he refers to "les points nommés nombrils, brulans ou foyers" proves only that he used the language of his learned circle and not that he had read Kepler. A man who has a new idea is self-educated.

In February, 1630, Desargues received a privilege to publish his work,[5] but his earliest surviving publication is his pamphlet on perspective of 1636.[6] This was devoted to the construction of his "perspective ladder," as he

[2] Thus Alberti uses "troncho," "nodo," and "virgulti," and Desargues "tronc," "nœud," and "rameau" and "brin."

[3] "J'estime beaucoup M. Desargues et d'autant plus qu'il est lui seul inventeur de ses coniques." Poudra, *Œuvres de Desargues,* I, 22.

[4] Poudra, I, 210.

[5] See the second page following the dedication of Abraham Bosse's *Pratique du Trait à Preuves* . . . *pour la Coupe des Pierres en l'Architecture* (Paris, 1643).

[6] "Exemple de l'une des manières universelles du S.G.D.L. Touchant la pratique de la perspective. . . ." At the end "A Paris, en May 1636." Poudra never saw either of the two surviving copies of the original, and reprinted the text from the reprint at the end of Bosse's *Maniere universelle de M. Desargues pour pratiquer la perspective* (Paris, 1648). The title as given by Poudra is incorrect.

called it. The "ladder" was a construction by which an artist could get his picture into perspective without using a distance point outside his picture. It was ingenious but mathematically unimportant. However, several paragraphs at the end, having nothing to do with the "ladder" and apparently added as a sort of afterthought, mark the beginning of an epoch in the histories of geometry and philosophy. To put it shortly, these paragraphs contain an analysis of the intersections of the several planes defined by the lines in the perspective construction.[7] This analysis shows that the visual convergence of parallel lines is the logically necessary result of the geometrical definitions of point, line, and plane, in terms of each other, devoid of and prior to all metrical assumptions. It follows from this that that convergence is neither "an illusion" nor a "mere appearance" but an even more fundamental geometrical fact than any of the theorems arrived at by metrical reasoning—as, for example, that about the square of the hypotenuse. This single unanswerable stroke punctured the fallacy inherent in one of the most basic and most tenaciously and long held of all Greek ideas. Had Socrates-Plato discovered it, he would have had to sacrifice much more than a Pythagorean ox, for it indicated the existence of a hitherto unknown but much more basic geometry than that which was known to the Greeks, and which was qualitative and not metrical.

[7] See Poudra, I, 81 ff. Let us, with Desargues, call the lines to be projected the subjects, the lines corresponding to them on the picture plane the appearances, and the line between the eye and any point on the picture plane the eye line. The eye line is not parallel to the picture plane. Each subject that intersects, or is parallel to, the eye line, also lies on a plane containing both its appearance and the eye line. This plane intersects the picture plane. A line that lies on each of two different planes is necessarily their intersection. The intersection of the two planes necessarily contains the point at which the eye line intersects the picture plane. In other words, the appearances all intersect in a single point.

When Descartes heard that Desargues was at work on a book on conic sections he was astonished, because, as he said, Apollonius could only be made easier by the use of algebra.[8] Apparently it had never entered Descartes's head that there could be any other conics than that of Apollonius. When Desargues's book came out in 1639,[9] however, Descartes was one of the few men who approved its vocabulary and style and appreciated the great contribution that it contained. Nothing could have been more laudatory in its dry way than what Descartes said, or, as coming from him, more important.[10] The book began with a series of verbose statements or assumptions about lines and planes. To translate some of these into our modern terminology: Straight lines extend to infinity in both directions and there is no difference between a straight line and a circle with a radius of infinite length. Planes extend to infinity in all directions, every plane intersects every other plane, and the only difference between parallel planes and other planes is that parallel planes intersect in a line at infinity. Every line in a plane intersects every other line in the same plane, and the only difference between parallel lines and other lines is that parallel lines intersect in a point at infinity. By giving the point and line at infinity the same status of actuality as any other points and lines Desargues introduced a new definition of parallelism, based not on measurement of angles or of invariant distance apart but on a particular place of intersection. Among its odd re-

[8] Poudra, II, 135.

[9] *Brouillon proiect d'une atteinte aux evenemens des rencontres d'un cone avec un plan* (Paris, 1639).

[10] Descartes to Mersenne, "La facon dont il commence son raisonnement, en l'appliquant tout ensemble aux lignes droites et aux courbes est d'autant plus belle qu'elle est plus générale, et semble être prise de ce que j'ai coutume de nommer métaphysique de la géométrie, qui est une science dont je n'ai point remarqué qu'aucun autre se soit servi, sinon Archimède" (Poudra, II, 138).

sults are that a plane is a surface with only one side, and that two points on a line determine two segments.[11]

The contrast, however, between the Greek conics and those of Desargues is brought to view most immediately by the fact that, whereas in Greek practice and theory the facts about each particular case had to be worked out separately and by themselves, in those of Desargues each descriptive relation that was true of a pattern of straight lines and regular curves in one plane was also true of the projection of that pattern upon another plane, no matter what the angle of incidence of the two planes might be.[12] If any pattern of straight lines (and regular curves) had certain intersections with each other, then in its projection upon another plane those straight lines remained straight, and, no matter how much the regular curves might change in the course of projection—from circle to ellipse, parabola, hyperbola, or even to line pair—the intersections remained unchanged in their collineations, their betweennesses and order along each given line, whether it be a straight line or a conic. One result of this was that any descriptive theorem that could be proved of a pattern of lines in one plane was also true of the projection of that pattern on another plane. The proof of this is based upon considerations of the same kind that Desargues had used in his analysis and proof of the perspective construction (see p. 88 *ante*). Looked at in retrospect it seems almost incredible that the Greeks should not have discovered these things, which today seem intuitive in their simplicity and obviousness. The probable reason for this failure of the Greeks is that they were so ob-

[11] Such a surface can be made by giving one end of a strip of paper a half turn and then pasting it to the other end so that the strip becomes a band with a turn in it. If a pencil line is drawn along the middle of the band it will meet itself, and there will be no surface of the band that has not got the pencil line upon it.

[12] See Desargues's own statement (Poudra, I, 195 ff).

sessed by measuring and working out the relations between measurements in each of the separate conics that they never were able to see the descriptive qualities that ran invariantly through the whole series of conics.

The step from the limited "analogy" by which Kepler brought out the resemblance between the parabola and the other conics to the highly generalized conceptions and postulates of Desargues was an even greater and more important advance than that which Apollonius had taken beyond Menaechmus. It led immediately to a geometry that concerned itself with qualitative or positional relations instead of with metrical ones. Some of Desargues's proofs of this new geometry depend on the old fashioned notion of a metrical parallelism, as in his use of the theorem of Menelaus about the transversals of a triangle,[13] but nevertheless he produced a geometry in which straight lines, parallel lines, and the regular plane curves were reduced to the same status. There were no longer unbridgeable gaps between the different kinds of lines.

When we remember that all this happened roughly a hundred years before Saccheri demonstrated that parallelism was an assumption that could not be proved, and two hundred years before Lobachewski and Bolyai published the first non-Euclidean geometries, its imaginative and logical boldness can be appreciated. At the time it led to a quick flood of misunderstanding and angry polemic, and even to a lawsuit; but it all quickly blew over, Desargues went back to Lyons and the practice of architecture and engineering, and his book was forgotten. So far as known every printed copy of it has vanished. Had it not been that La Hire made a manuscript copy of it, which by some accident survived to be picked up by Chasles in a bookshop in the middle of the nine-

[13] Poudra, I, 111 and 145. Desargues calls it the theorem of Ptolemy, in whose book it appears.

teenth century, it would today be unknown. La Hire made use of some of the discoveries in it in his own somewhat later perspective geometry, and for more than a hundred and fifty years he enjoyed the credit for them, but otherwise the many discoveries contained in Desargues's book had to be made one by one by later workers, principally in the first half of the nineteenth century. When finally republished by Poudra in his edition of the *Oeuvres* of 1864, Desargues's conics came to the world not as a series of marvellous discoveries but as an historical curiosity containing nothing that was not already known.

For today's purposes it is enough to say that at the end of his short text Desargues says that some of his theorems contain many of those of Apollonius, and that, leaving aside the lemmas, four of them contain the whole of conics.[14] It was boastful, but for its time there was a great deal in it.

Out of all this, however, came a little broadside and a short appendix to another man's book that, while taking a long time to become known by the world, eventually had very important effects on geometry. In the broadside, privately printed in 1640,[15] Blaise Pascal, then sixteen years old, by the use of Desargues's methods, enunciated his famous theorem about the mystic hexagram, i.e., in its modern restatement, that the cross joins of a hexagon inscribed in a conic intersect in three points that lie on a

[14] Poudra, I, 227: ". . . apres les lemmes ou premices, quatre de ces propositions contiennent le dissection entière du cone par le plan."

[15] "Essay pour les coniques. par B. P." A reproduction in facsimile will be found in volume 1 of the *Œuvres de Blaise Pascal*, edited by Brunschvicg and Boutroux (Paris, 1908). An English translation is available in D. E. Smith's *A Source Book in Mathematics* (New York, 1929). Only two copies of the original are said to survive, one in Paris, the other among Leibniz's papers. Apparently it was not available to the public until reprinted in the 1779 edition of Pascal's works. Pascal's treatise on the conics was never printed, and the manuscript vanished after having entered the hands of Leibniz.

line.[16] It is said that it summed up several hundreds of the disparate old Greek theorems, which now appear merely as particular cases of Pascal's theorem.

The appendix consisted of a few pages that Desargues contributed to Bosse's book on perspective of 1648,[17] where they lay unseen and unknown until Servois discovered them in 1804. In this appendix Desargues both stated and proved for the first time·what is now known as his theorem, i.e., that if the three lines joining the corresponding vertices of two triangles intersect in a point, then the corresponding sides of the two triangles intersect in three points on a line, and vice versa. (See diagram on page 97.)

<hr>

[16] Compare the diagrams on p. 41 *ante,* which represent hexagons inscribed in a circle and in two straight lines. There is a very great variety of ways of doing this. A hexagon is a figure that has six sides that may cross one another within the figure.

[17] A. Bosse, *Maniere universelle de M. Desargues pour pratiquer la perspective* (Paris, 1648). Bosse, well known as an etcher, was Desargues's pupil, friend, expositor, and public defender. His book on perspective according to Desargues's principles met with the approval of the latter. It was the first book on perspective to be based on what is now known as perspective geometry. Desargues's little appendix is one of the basic texts in the history of geometry. It is to be noted that in addition to giving Desargues's theorem for the first time, it accompanied it by a theorem equivalent to the invariance of anharmonic ratios in projection, under the title "Proposition fondamentale de la pratique de la perspective."

THE GREEKS AGAIN, and WHAT THEY MISSED

The Greeks had had logical equivalents of particular cases of these theorems of Desargues and Pascal, but having no generalizing capacity and no theory of perspective or perspective geometry they saw little in them. This goes to show the vast difference between a theorem and its logical equivalents.

The earliest of these Greek things was Euclid's celebrated "porism." Its history from the early third century B.C. down to the second half of the nineteenth century of the Christian era is very odd because of the way in which generation after generation of men· missed its content and its necessary logical implications. Euclid, who flourished about 300 B.C., wrote a book on "porisms," which, like the very meaning of the word porism, has been lost. Pappus in the second or third century after Christ summed up ten of Euclid's porisms in one enunciation, which occurs in the preface to the Seventh Book of Pappus' own *Collections*. This is what is referred to as "Euclid's Porism." As translated by Heath [1] it reads as follows:

"If, in a system of four straight lines which cut one another two and two, three points on one straight line

[1] *History of Greek Mathematics*, I, 432.

be given, while the rest except one lie on different straight lines given in position, the remaining point also will lie on a straight line given in position."

I can recommend the unaided decipherment of that quotation as being one of the best introductions to Greek thought that I have met. When we work with literal translations of Greek mathematical texts, instead of restatements of them in modern terms, we see the handicaps presented by a lack of a highly developed terminology and system of symbolic notation. That the Greeks, suffering from such a handicap, should have progressed as far as they did is very remarkable, but it is even more remarkable that they never realized the handicap and the reasons for it. It had much to do with their failure to make or discover the great general theorems in geometry—as well as in a great many other things.

The Porism is much more easily understood in the modern equivalent given by Chasles to the effect that if a variable triangle is swung from the intersections of its three extended sides with a straight line in such a way that two of its vertices travel along two given straight lines then the third vertex also travels along a determined straight line.[2]

If, using a straight-edge, we try our hands at drawing Euclid's swinging triangle, we rapidly discover that when two of the lines traversed by the vertices intersect on our drawing board, no matter how big that is, then the third line also passes through their point of intersection. That it should do this is an inherent quality or characteristic of straight lines. It seems impossible that the Greeks should not have been aware of this empirical fact, and yet, so far as is known, they paid no attention to it and failed to investigate its mathematical proof and its implications and content. In a way it involves no

[2] M. Chasles, *Les trois livres de Porismes d'Euclide* (Paris, 1860), p. 22.

more than two sections of a triangular pyramid instead of a cone, but it is much more interesting and more basic. The earliest known statement of the necessary concurrence of the three lines is that made by Desargues in his appendix to the Bosse of 1648, where, moreover, he gave proofs of it in three dimensions and in two.[3] The extraordinary thing is that with three dimensions to work in (i.e., in a three-dimensional space or on a plane that is part of a three-dimensional space) his proof depends only on the ideas of point, line, and plane, and is free from all metrical notions. In all essential respects it is merely a development of the ideas used by him in his

DESARGUES'S THEOREM

EUCLID'S PORISM

[3] The swinging triangle is shown in two positions in its swing, and appears as the two triangles ABC and A'B'C'. When these lie in two different planes, the two planes intersect on the line XZ. The lines of each pair, AB and A'B', AC and A'C', and BC and B'C', intersect on the line XZ—and each pair lies in a different plane. The lines AA' and BB' therefore lie in a plane and intersect each other. This is also true of BB' and CC', and of AA' and CC'. The line CC' intersects both AA' and BB', but does not lie in the plane defined by them and thus intersects that plane in a point, which can only be the intersection of AA' and BB . The converse is proved by similar reasoning. The modern proof, when the two triangles ABC and A'B'C' lie in the same plane in a three-dimensional space, treats them as projections from two different centers of a triangle in another plane.

proof of the perspective construction (*vide* p. 88 *supra*).
It is practically the same as that to be found in many
modern books on perspective geometry. In a strictly two-
dimensional space, which after all is as great an abstrac-
tion as a space of eight or ten dimensions, the theorem is
provable only by the introduction of metrical notions;
Desargues used for the purpose the theorem of Menelaus
(first century after Christ) about the transversals of a
triangle.

Why the Greeks should have come no closer to De-
sargues's Theorem than the rather unimportant corollary
of it contained in Euclid's Porism is anyone's guess. The
Theorem holds true just as well when the point of con-
currence of the three lines is at infinity as when it is at a
finite distance, and it has no dependence on metrical
notions in a space of three dimensions. Thus, perhaps,
there may be alleged in explanation of the Greek failure
to take interest in it their metrical habit of thinking in
terms of segments of lines (i.e., a straight line "is the
shortest distance between two points") rather than in
terms of lines that have no ends (i.e., a line is "a closed
series"), and their inveterate postulate that there were
such things as coplanar lines that, no matter how far
extended, could not meet. It is a prime case of their lack
of freedom of postulation and the trouble it got them
into. In any event it is one of the greater misses in the
history of thought. They had the cornerstone in their
hands but they saw no importance in it. The Porism, in
other words, presents another and a most important ex-
ample of how the Greeks repeatedly came right up to the
doors of modern geometry, and then, because they could
not break away from their tactile-muscular assumptions,
averted their faces and turned away from it.

Pappus, also in his seventh book, gives a series of
theorems embodying particular cases of what modern
geometers have recognized as the single proposition they

refer to as the invariance of anharmonic ratios in projection.[4] Pappus' series of theorems provides a most apt illustration of the Greek intuitional habit of seeing and dealing with particular cases instead of general propositions, and of treating them as separate and distinct problems. Of these theorems several, apparently first enunciated by Pappus, are particular cases of the modern theorem that the cross joins of a hexagon inscribed within two straight lines intersect in three points that lie on a straight line.[5] This last, often referred to in modern mathematical books as Pappus' Theorem, is the statement of another empirical fact that, like Desargues's Theorem, comes out in drawing with a straight-edge, and that constitutes another inherent quality or characteristic of straight lines. A proposition in the geometry of the plane, it has not yet been proved by purely projective means in any number of dimensions. It can be proved in particular cases by the introduction of Euclidean metrical postulates, and generally by the introduction of the so-called axioms of order of points on a line—which, incidentally were unknown to the Greeks. It is, therefore, for the purposes of perspective geometry either proved by the axioms of order or taken as itself an axiom.

[4] If four straight lines, a, b, c, and d, intersect in a point, and these lines are intersected by any other straight lines, respectively in the points A, B, C, D; A', B', C', D'; A'', B'', C'', D''; etc., then

$$\frac{AC}{BC} : \frac{AD}{BD} = \frac{A'C'}{B'C'} : \frac{A'D'}{B'D'} = \frac{A''C''}{B''C''} : \frac{A''D''}{B''D''}, \text{ etc.}$$

The number $\frac{AC}{BC} : \frac{AD}{BD}$ is called the anharmonic or cross ratio. It is not only a metrical but a descriptive property and is not affected by projection.

For a list of these theorems of Pappus' and an abridged statement of their content, see Heath, *History of Greek Mathematics*, II, 419 ff. The individual theorems are given in extenso in Paul Ver Eecke's French translation of *Pappus d'Alexandrie, La Collection Mathématique* (Paris and Bruges, 1933).

[5] Two of the diagrams on p. 41 *ante* represent particular cases.

Desargues's Theorem is the basic theorem in the modern subject known as the Foundations of Geometry. Much as it does in spaces of two and more dimensions, it does not provide the geometrical equivalent of the commutative law or assumption (i.e., that A times B equals B times A), and taken by itself is incapable of dealing with irrational points (i.e., points which correspond to the irrational numbers of arithmetic). These two lacks are taken care of by the adoption into the Desarguesian geometry either of Pappus' Theorem as an axiom or of the axioms of order. To do either involves no contradiction with Desargues's Theorem and vastly extends its power.[6]

The strategic position of the Theorems of Desargues and Pappus in the Foundations of Geometry can, perhaps, be judged by the fact that the first of the four volumes of H. F. Baker's standard *Principles of Geometry* is devoted exclusively to them, their proofs, their content, and the logical problems they raise. The philosophical importance of the two theorems can hardly be too greatly emphasized. Their bearing upon what we mean by "truth" in connection with a logical operation is obvious.

Because of the fascination exercised by Descartes's coordinate geometry, which was published in 1637 as an appendix to the first edition of his *Discours de la Méthode,* the mathematical world went off on the analytical tack and paid little attention to synthetic geometry until about 1800, when it was again taken up by a remarkable group of Frenchmen at the head of whom were Monge, Carnot, Gergonne, and Poncelet.

[6] As to the logical equivalence of Pappus' Theorem and the commutative law, see D. Hilbert, *The Foundations of Geometry* (La Salle, 1938), § 31 *et seq.* The axioms of order are given in the standard textbooks, but as concise a statement as any is that given by A. N. Whitehead in the *Encyclopaedia Britannica* (11th ed.), XI, 731.

In 1822 Poncelet published his famous *Traité des propriétés projectives des figures,* in which he presented to the world the first systematic development of perspective geometry. In it he propounded his well-known theory of geometrical continuity. In Poncelet's method "the various sensuously possible cases of a figure are not, as in Greek geometry, individually conceived and investigated, but all interest is concentrated on the manner in which they mutually proceed from each other. In so far as an individual form is considered, it never stands for itself alone but as a symbol of the system to which it belongs and as an expression for the totality of forms into which it can be transformed under certain rules of transformation." In the geometry of the Greeks, to the contrary, "every difference in the arrangement of the given and sought lines of a problem presents a new problem in regard to the proof; to every difference in the total sensuous appearance of a figure corresponds a difference in interpretation and deduction. A problem, which modern synthetic geometry solves by a single construction, was analysed by Apollonius into more than eighty cases, differing only in position. The unity of the constructive principles of geometry is hidden by the specialization of its particular forms of which each one is conceived as irreducible." [7] A more profound and illuminating statement of the difference between Greek and modern geometry is contained in the following sentences by A. N. Whitehead: "In those days, mathematics was the science of a static universe. Any transition was conceived as a transition of static forms. Today we conceive of forms of transition. The modern concept of an infinite series is the concept of a form of transition, namely, the character of the series of the whole is such a form." [8]

[7] Cassirer, *Substance and Function,* p. 78 and p. 70.

[8] A. N. Whitehead, *Modes of Thought* (New York: The Macmillan Co., 1938), p. 112.

Until well into the last century the axioms and postulates of Euclid were accepted as representative of the actual space of daily experience, and the geometry erected on them was accepted as the science of that space. In the 1830's, Lobatchewski and Bolyai invented non-Euclidean geometry, which with very different assumptions produced results empirically indistinguishable from those of Euclidean geometry. In the 1840's, Cayley and Grassmann invented conceptual spaces of more than three dimensions. Out of all this came an interest in sets of arbitrarily chosen postulates and the geometries that could be erected on them. It came close to being a reduction of geometry to a form of pure logic, for these geometries make no assumption that their postulates represent actual space, and they assert only that given those postulates such and such consequences follow from them. "Thus Geometry no longer throws any direct light on the nature of actual space. But indirectly, the increased analysis and knowledge of possibilities, resulting from modern Geometry, has thrown immense light upon our actual space." [9] Incidentally, all this has had very disastrous consequences for the ideas about space of many of the older philosophers, and has led to great changes in logic itself.

In the 1840's Von Staudt all but succeeded in eliminating metrical ideas from perspective geometry and turning it into a pure geometry of position. The task appears to have been completed by subsequent workers, notably F. Klein, about 1875.[10] In 1859 Cayley, who had been thinking very hard about anharmonic ratios and the line at infinity, perceived that perspective geometry instead of being a minor province in the empire of Euclid was logically a much vaster empire of which Euclidean

[9] Russell, *Principles of Mathematics*, p. 374.
[10] See *Encyclopédie des Sciences Mathématiques*, Tome III, vol. 1, p. 89, and vol. 2, p. 87.

geometry was a subordinate division. As developed by himself and others, Cayley's idea "aboutit finalement à une construction dans laquelle les differentes géométries non-euclidiennes sont, comme la géométrie euclidienne, fondées sur une base purement projective."[11]

There can be no question about the great role played by perspective geometry in the astonishing nineteenth-century mathematical development and in the origins, on the one hand, of the current philosophy of organism, and on the other, of modern logic. As to these last two things it suffices to mention the names of two men, A. N. Whitehead and Bertrand Russell.

The fate of Greek logic is, perhaps, sufficiently indicated by the following quotation from the preface to Alfred Tarski's *Introduction to Logic* (New York: Oxford University Press, 1941): "Secondly, apart from two rather short passages, the book gives no information about the traditional Aristotelian logic, and contains no material drawn from it. But I believe that the space here devoted to traditional logic corresponds well enough to the small role to which this logic has been reduced in modern science; and I also believe that this opinion will be shared by most contemporary logicians."

One significant difference between Greek metrical and modern relational geometry remains to be mentioned. If, as appears to be the case in Greek geometry, measurements are no more than the counted motions of men's bodies (*vide* Euclid I, 4), then Greek geometry says that if you, a man, make certain counted motions in a certain order you will discover that certain other counted motions are also possible for you—in other words, Greek geometry begins and ends with you and your motions and gets you no further than that towards any knowledge of the ultimate reality that science has

[11] F. Enriques, in *Encyclopédie des Sciences Mathématiques*. Tome III, vol. i, p. 100.

traditionally, and so naïvely, dreamed of reaching. Greek geometry, which was considered to be the ultimate science of actual space, had the standing of a creed, and thus became a straitjacket for both thought and knowledge. Modern geometry says that if a group of undefined entities bear certain postulated relations to each other then they bear certain other relations to each other, quite without regard to you or the count of your motions. Modern theoretical geometry thus enables us at will to create special geometries. Because of this we are no longer in the procrustean situation of having to tailor our observed facts to a standard invariant geometry of independently existing things. Just as our observed facts have become forms of transition so we have become able to fit them with geometries tailored to their nature. Thus, it may be that the basic difference between the two kinds of geometry, paradoxical as it may seem, is that Greek geometry is thoroughly subjective, and that the modern geometry of abstract relations comes as near to being objective as the general epistemological and logical predicaments permit. If we follow this up, it appears that the "relative," so far from being "illusionistic" and "transient," is the best lead we have towards the "permanent" and "essential." In any event, something of this kind seems to be thought in the advanced regions where the boundary between science and metaphysics grows hazy, and where the scientists, in order to think effectively about what they are doing, are willy-nilly becoming metaphysicians.[12]

[12] In view of the close relationship between mathematics and physics, it is interesting to see that Bertrand Russell in his *The Analysis of Matter* (New York, 1927, p. 160) indicates the possibility of classifying the sorts of physics according to the sense returns on which they are based, as those of muscular action, touch, and sight, and points out that sight physics has gradually got the upper hand of the others and, in the theory of relativity, has won out over them.

CHAPTER X

THE SYNCHRONISM
BETWEEN GEOMETRICAL
and OTHER IDEAS

To turn back upon our steps for a little: It is interesting
to notice how the great advances in geometry and per-
spective have synchronized with great developments in
art. In the great majority of cases it is impossible to find
any direct cross influence between the two, but it is al-
ways to be remembered that, ever since the Renaissance,
artists have had need in their business for a working
knowledge of perspective, and that among them there
have always been men who were great experts in per-
spective theory. In calling attention to the following
names and dates I take it for granted that the accom-
plishments of the artists are familiar and need little or
no comment.

Alberti's essay of 1435 fell roughly halfway between
the deaths of Masaccio in 1427 and of the younger Van
Eyck in 1440, and during the working lives of Donatello
and Luca della Robbia—four revolutionists who em-
phasized the solidity and the personal characteristics of
their figures and who put them in close emotional rela-
tionship with one another in an approximation to a
single three-dimensional space. Pelerin's book of 1505,

with its simpler solution of Alberti's problem, fell in the lifetimes of Raphael, the first great master of composition in depth, and of Michelangelo, possibly the greatest creator of volumes that modern times has produced. Vignola taught at Rome in the 1530's, at a time when Titian was in his stride. In the 1630's and 1640's, Desargues and Pascal were contemporaries of Claude, Velasquez, and Rembrandt, who in their several ways perfected the control over representation of space and of interrelated figures and objects within its envelope. Ver Meer of Delft was born in 1632. In the first half of the nineteenth century, Poncelet and von Staudt, who did such great work in perspective geometry, were contemporaries of Turner and Constable, who explored the atmosphere as none before them. During the second half of that century, when the geometers were finally eliminating metrical ideas from perspective geometry, there arose in France the Impressionist School of painters who deliberately strove to turn painting into a purely visual exercise devoid of the traditional tactile-muscular intuitions. While Monet, and others, did this with light and color, his contemporary Degas did it with form and on occasion carried perspective beyond its strict geometrical formulation and into the realm of the perspective of physiological optics.[1] In spite of the official popularity, from the sixteenth century on, of the academic theory and tradition of an abstract correctness in proportions and perspective, they seem to have produced few or no great or memorable artists. To an important extent the reason for this is probably that the academic artists have striven to combine in one abstract dogmatic representational scheme forms based upon the conflicting sense returns given by both the eye and the hand, that is, that

[1] E.g., in the floors of some of his paintings of the Foyer de Danse, in which at a certain distance the floor appears to rise and then fall away again.

they have worked with sets of premises marred by ir-reconcilable contradictions. In this respect painting, like many other things, has its peculiar logic to which lack of contradiction is essential. Ingres, masquerading as an academic, was in fact one of the most amazing and deliberate distortionists in the history of post-Renaissance design—for example, le Bain Turc, the Odalisque, and the portrait of Madame d'Haussonville—and was saved by the logical consistency within each of his canvases. Much the same thing is true of some of the Post-Impressionist work which happened to coincide in time with the development of the Einsteinian application of relativity to physics.

The second quarter of the nineteenth century—the period of Poncelet, von Staudt, Turner and Constable— was also the period in which Fox Talbot and Daguerre developed photography from laboratory to practical process. Photography, omitting the draughtsman, produced pictures in which, subject to the shortcomings of the lens, mathematical perspective was inherent. The first serious book to be illustrated with photographs was Sir William Stirling Maxwell's *Annals of the Artists of Spain*.[2] The basic patents on the modern cross-line half-tone processes were taken out in the 1880's and 1890's. By the end of the first decade of this century photography had become the normal method of book, magazine, and newspaper illustration. Today we are flooded with photographic pictures, i.e., pictures in which geometrical perspective has been automatically incorporated. The result of this is that we have become so habituated to mathematical perspective that most honest citizens of today are dis-

[2] They are contained in the rare fourth volume of the first edition, which is dated 1847. They are "calotypes" made by Fox Talbot. As the Stirling Maxwell was the first book on art to be illustrated with photographs or photomechanical reproductions, it must be regarded as the cornerstone of modern connoisseurship.

tinctly bothered by pictures in which any deviation from it is easily recognizable, and such deviation is resented and denounced as ignorant, inaccurate, willful, and any number of other things, including degenerate and immoral. Strong as the mathematical convention of perspective had become in picture making before the pervasion of photography, that event definitely clamped it on our vision and our beliefs about "real" shapes, etc. The public has come to believe that geometrical perspective, so long as it does not involve unfamiliar points of view, is "true," just as a long time ago it believed that the old geometry of Euclid was "the Truth."

An odd and interesting fact is that physiological optics and perspective are actually in many ways very different from the monocular optics and perspective of the geometer and the photographic lens, and that our eyes, when we can invent situations in which they are not dominated by "conditioning," give us returns that frequently are at variance with the constructions of the drawing board and the camera. All the world talks about "photographic distortion," but without realizing that the "distortion" is no more in the photograph than it is in our mental habits and our visual mechanisms. The subject of physiological optics and its differences from mathematical or camera optics is little known to the world in general. Much work on it has been done, but many questions remain unsolved. It is not improbable that the most important work on the subject since the days of Helmholtz is that now being done at Dartmouth by Adelbert Ames and his colleagues. Ames has thrown light upon many curious things, notably anisiconia,[3] which were

[3] Anisiconia is the name for the condition in which the images produced in the right and left eyes are different in size. It can result in very remarkable distortions of vision. It is quite common and can be most distressing. In a perfect pair of eyes the two images are of the same size.

unknown before he began his work. All this lies far beyond my capacity to deal with, but I call attention to it because it shows up in the most perfect way the essential fact that the forms produced by our modern geometrical perspective are conventions which, in spite of their practical utility and philosophical importance, are only a loose general rationalization of the actual sense returns of physiological binocular vision.

Thanks in large measure to the nineteenth-century development of geometrical theory, the notion of mathematical relativity gradually became a commonplace. Beginning perhaps with Ernst Mach in the early 1880's, even the scientists have gradually realized—Descartes to the contrary notwithstanding—that a knowledge of the history of a science is of the greatest importance for anyone who would understand the science itself in its present-day condition.[4] Early in this century "relativity" made its astonishing entrance into physics and thereby brought about a very complete change in ideas of "scientific truth." Simultaneously with all this there grew up the comparative study of religions and philosophies. This development in turn synchronized with the rise of the great modern accumulations of works of art we call museums, which teach, if they teach anything, the story of art, and, incidentally to that, the story of the evanescence of "beauty" and consequently its peculiarly temporal and local quality. Today students of the histories of religion, philosophy, and art, are concerned with the evolution of thought and expression rather than with the pursuit of "The Truth" or "The Best." When men finally began to discuss the problem of the locus of beauty, it did not take long before the deadening aca-

[4] It is interesting to notice that there appears to be no available critical history of the growth and development of the general ideas that have determined the course of classical archaeology and their effect upon its theories and "facts."

demic scepticism, which necessarily accompanied the idea of beauty as a static absolute that had been revealed once and forever and given into the custody of a self-elected group, gave place to a recognition that the unfolding and fading of beauty is an eternally living, growing activity participated in at all times by all of mankind as an evolving process of self-discovery and self-realization. The only thing essential to that expression of human character we call art is its constant "becoming," which is as indefinable as life itself.

CONCLUSION

The result of the long history that I have so rapidly and superficially recounted has been, in almost every respect, a shift over to intuitions, intellectual habits, ideas, knowledges, and ideals, as far removed from those of ancient Greece as can well be imagined.

There is much talk of how much we owe the ancient Greeks, and of the persistence, revivals, and renaissances of their ideas, but most of this talk seems to be based on some vestigial legend of a "Golden Age," which in this case extended for several hundred years in a definitely historical time and had its capital at a specific place, Athens. In general those who talk this way show little acquaintance with what we owe to other peoples and other times, let alone with what we owe to ourselves. It is rarely pointed out explicitly that ideas are not mere words and phrases, but contents, relations, and implications, and that these undergo basic changes as they are used in novel conjunctions. Change the context or the assumptions underlying a phrase and you change its content and character. The age of an idea, so far from being evidence of its validity, casts doubt on its soundness.

Unlike the world of the Greeks, the world we live in is not static and neither is it discontinuous. What we know and study is forms of transition. Three atomic bombs that exploded during the writing of this essay were more incompatible with ancient ideas than with the places where they exploded. There has thus been a

complete change in the basic postulates of thought, and with that change the fundamental Greek notions, from mathematics to art and all that lies in between, have become only another variety, albeit an exceedingly suggestive and interesting one, in the great historical collection of such things. The greater number of Greek ideas that still pass current carry on because they were encysted in the religious thought and practice of Christianity, where they are so disguised and so incompatible with our conventional misconception of the Greeks that they are rarely recognized for what they are. As to the remaining ideas of the Greeks, a few of the practical ones, such as those of Euclid's geometry, live on because of their value as tools in the ordinary business of life, but most of them that were on a level higher than that of elementary mechanical practicality have been discarded because of their failure to provide workable answers in an evolving world. Implicit in much of Greek ethical thought is the assumption of a broad base of slave labor —a postulate that, for those who think, invalidates most of the old-school-tie results so charmingly erected on it. The Greek thinkers who are still of interest in the forward looking intellectual business of life seem to be those, like Zeno of Elea and Plato, who, asking endless questions, practiced dialectic but gave few answers and erected no systems. The science and the dogma of the Greeks have vanished into the thin air of dead history. In the creative arts, Greek ideas have been discarded for the simple reason that their content has been exhausted. They provide no novelty. To the extent that they still pass current in the studios, they are merely the safe empty clichés of the uncreative.

Greek rationalism, great as may have been its advances over its predecessors, defeated itself in the realm of pure thought, as also in those of art and practice. The Greeks were critical of everything except their premises and

their logic, both of which were faulty. Their deductional system at best was a tautology and provided only a blocked road. To escape from it some method of carefully adventurous induction was needed, and the justification and data of that lay outside logic. As was said by the greatest of the modern sceptics, "Le coeur a ses raisons, que la raison ne connaît point."

In a way we get the summation of the story in Werner Jaeger's remark that Aristotle's "historical importance as the intellectual leader of the West is certainly not lessened by the fact that the evolution of independent philosophical achievement in European culture has taken the form of a five-hundred-years' struggle against him. Seen from the modern point of view, however, he is merely the representative of the tradition, and not a symbol of our own problems or of the free and creative advance of knowledge." [1]

It is deserving of thought that, at two crucial moments in the course of this history, one in the early fifteenth century, when the worship of the rediscovered classical forms was beginning, the other in the early years of the seventeenth century, when a revived Aristotelianism was at the peak of its power and cruelty, it should have been a many-sided artist, Alberti, and an architect and engineer, Desargues, laboring at what for them were practical problems of their arts, who took the first of the imaginative revolutionary steps that eventually led to the perspective of central projection and section and through that to the discovery of nonmetrical geometry as the most highly generalized science of order. Looked at in retrospect their discoveries appear to have been among the most "decisive battles" in the long struggle of Western Europe to free itself from the inhibiting burden of the Greek tradition and to provide its new vision with a logical apparatus and a philosophical justification.

[1] See W. Jaeger, *Aristotle* (Oxford University Press, 1934), p. 368.

A CATALOG OF SELECTED
DOVER BOOKS
IN ALL FIELDS OF INTEREST

A CATALOG OF SELECTED DOVER
BOOKS IN ALL FIELDS OF INTEREST

CONCERNING THE SPIRITUAL IN ART, Wassily Kandinsky. Pioneering work by father of abstract art. Thoughts on color theory, nature of art. Analysis of earlier masters. 12 illustrations. 80pp. of text. 5⅜ x 8½. 23411-8 Pa. $3.95

ANIMALS: 1,419 Copyright-Free Illustrations of Mammals, Birds, Fish, Insects, etc., Jim Harter (ed.). Clear wood engravings present, in extremely lifelike poses, over 1,000 species of animals. One of the most extensive pictorial sourcebooks of its kind. Captions. Index. 284pp. 9 x 12. 23766-4 Pa. $12.95

CELTIC ART: The Methods of Construction, George Bain. Simple geometric techniques for making Celtic interlacements, spirals, Kells-type initials, animals, humans, etc. Over 500 illustrations. 160pp. 9 x 12. (USO) 22923-8 Pa. $9.95

AN ATLAS OF ANATOMY FOR ARTISTS, Fritz Schider. Most thorough reference work on art anatomy in the world. Hundreds of illustrations, including selections from works by Vesalius, Leonardo, Goya, Ingres, Michelangelo, others. 593 illustrations. 192pp. 7⅛ x 10¼. 20241-0 Pa. $9 95

CELTIC HAND STROKE-BY-STROKE (Irish Half-Uncial from "The Book of Kells"): An Arthur Baker Calligraphy Manual, Arthur Baker. Complete guide to creating each letter of the alphabet in distinctive Celtic manner. Covers hand position, strokes, pens, inks, paper, more. Illustrated. 48pp. 8¼ x 11. 24336-2 Pa. $3.95

EASY ORIGAMI, John Montroll. Charming collection of 32 projects (hat, cup, pelican, piano, swan, many more) specially designed for the novice origami hobbyist. Clearly illustrated easy-to-follow instructions insure that even beginning papercrafters will achieve successful results. 48pp. 8¼ x 11. 27298-2 Pa. $2.95

THE COMPLETE BOOK OF BIRDHOUSE CONSTRUCTION FOR WOODWORKERS, Scott D. Campbell. Detailed instructions, illustrations, tables. Also data on bird habitat and instinct patterns. Bibliography. 3 tables. 63 illustrations in 15 figures. 48pp. 5¼ x 8½. 24407-5 Pa. $2.50

BLOOMINGDALE'S ILLUSTRATED 1886 CATALOG: Fashions, Dry Goods and Housewares, Bloomingdale Brothers. Famed merchants' extremely rare catalog depicting about 1,700 products: clothing, housewares, firearms, dry goods, jewelry, more. Invaluable for dating, identifying vintage items. Also, copyright-free graphics for artists, designers. Co-published with Henry Ford Museum & Greenfield Village. 160pp. 8¼ x 11. 25780-0 Pa. $9.95

HISTORIC COSTUME IN PICTURES, Braun & Schneider. Over 1,450 costumed figures in clearly detailed engravings–from dawn of civilization to end of 19th century. Captions. Many folk costumes. 256pp. 8⅜ x 11¾. 23150-X Pa. $12.95

THE INFLUENCE OF SEA POWER UPON HISTORY, 1660–1783, A. T. Mahan. Influential classic of naval history and tactics still used as text in war colleges. First paperback edition. 4 maps. 24 battle plans. 640pp. 5⅜ x 8½. 25509-3 Pa. $12.95

THE STORY OF THE TITANIC AS TOLD BY ITS SURVIVORS, Jack Winocour (ed.). What it was really like. Panic, despair, shocking inefficiency, and a little heroism. More thrilling than any fictional account. 26 illustrations. 320pp. 5⅜ x 8½. 20610-6 Pa. $8.95

FAIRY AND FOLK TALES OF THE IRISH PEASANTRY, William Butler Yeats (ed.). Treasury of 64 tales from the twilight world of Celtic myth and legend: "The Soul Cages," "The Kildare Pooka," "King O'Toole and his Goose," many more. Introduction and Notes by W. B. Yeats. 352pp. 5⅜ x 8½. 26941-8 Pa. $8.95

BUDDHIST MAHAYANA TEXTS, E. B. Cowell and Others (eds.). Superb, accurate translations of basic documents in Mahayana Buddhism, highly important in history of religions. The Buddha-karita of Asvaghosha, Larger Sukhavativyuha, more. 448pp. 5⅜ x 8½. 25552-2 Pa. $9.95

ONE TWO THREE . . . INFINITY: Facts and Speculations of Science, George Gamow. Great physicist's fascinating, readable overview of contemporary science: number theory, relativity, fourth dimension, entropy, genes, atomic structure, much more. 128 illustrations. Index. 352pp. 5⅜ x 8½. 25664-2 Pa. $8.95

ENGINEERING IN HISTORY, Richard Shelton Kirby, et al. Broad, nontechnical survey of history's major technological advances: birth of Greek science, industrial revolution, electricity and applied science, 20th-century automation, much more. 181 illustrations. ". . . excellent . . ."–*Isis.* Bibliography. vii + 530pp. 5⅜ x 8½. 26412-2 Pa. $14.95

DALÍ ON MODERN ART: The Cuckolds of Antiquated Modern Art, Salvador Dalí. Influential painter skewers modern art and its practitioners. Outrageous evaluations of Picasso, Cézanne, Turner, more. 15 renderings of paintings discussed. 44 calligraphic decorations by Dalí. 96pp. 5⅜ x 8½. (USO) 29220-7 Pa. $4.95

ANTIQUE PLAYING CARDS: A Pictorial History, Henry René D'Allemagne. Over 900 elaborate, decorative images from rare playing cards (14th–20th centuries): Bacchus, death, dancing dogs, hunting scenes, royal coats of arms, players cheating, much more. 96pp. 9¼ x 12¼. 29265-7 Pa. $11.95

MAKING FURNITURE MASTERPIECES: 30 Projects with Measured Drawings, Franklin H. Gottshall. Step-by-step instructions, illustrations for constructing handsome, useful pieces, among them a Sheraton desk, Chippendale chair, Spanish desk, Queen Anne table and a William and Mary dressing mirror. 224pp. 8⅛ x 11¼. 29338-6 Pa. $13.95

THE FOSSIL BOOK: A Record of Prehistoric Life, Patricia V. Rich et al. Profusely illustrated definitive guide covers everything from single-celled organisms and dinosaurs to birds and mammals and the interplay between climate and man. Over 1,500 illustrations. 760pp. 7½ x 10⅛. 29371-8 Pa. $29.95

Prices subject to change without notice.

Available at your book dealer or write for free catalog to Dept. GI, Dover Publications, Inc., 31 East 2nd St., Mineola, N.Y. 11501. Dover publishes more than 500 books each year on science, elementary and advanced mathematics, biology, music, art, literary history, social sciences and other areas.